EUROPEAN
ENAMELS

Isa Belli Barsali

EUROPEAN ENAMELS

CASSELL
LONDON

Cassell Publishers Limited
Artillery House, Artillery Row
London SW1P 1RT

Translated by Raymond Rudorff from the Italian original
Lo smalto in Europa

© Gruppo Editoriale Fabbri, Bompiani, Sonzogno, Etas S.p.A., Milan 1966, 1984

This edition 1988

British Library Cataloguing in Publication Data
Barsali, Isa Belli
European enamels. — (Cassell's styles in art).
1. European enamels
I. Title II. Lo smalto in Europa. *English*
738.4'094

ISBN 0-304-32179-6

Printed in Italy by Gruppo Editoriale Fabbri, Milan

CONTENTS

At all times in history, objects in precious metals such as ornaments, liturgical instruments and domestic utensils, have been colourfully decorated either with shiny gems, hard stones, rock crystals, mother-of-pearl and corals or by the inlaying of cameos and miniatures. Consequently goldsmiths and jewellers always made use of a wide variety of materials for combining brilliant colours with the sheen of gold and other precious metals. From earliest times, such precious materials were also combined with enamel, which although not precious in itself had a beauty of its own because of its brilliant range of colours.

In its modern sense, the term 'enamel' was first used in the late Middle Ages instead of the Latin *vitrum* and it is derived from the Frankish *smalt*, itself derived from the Germanic *smaltjan* (compare with the modern German *schmelzen*, to smelt).

The popularity of enamel throughout the ages was

due not only to its great variety of colours but also to its durability and resistance to wear. As it is rustless, it cannot be tarnished by time and it can only be destroyed or damaged if given a very hard blow with some sharp object. Enamel is basically composed of one or more layers of glass obtained by the fusion of special pastes, and it may therefore be described as a mixture of soda and potassium silicates with silica and lead oxide. Consequently all the ancient civilisations that practised glassmaking learned the technique of enamelling metal surfaces. The enamel pastes were obtained by laborious and careful grinding of glass under water in a hard mortar. The water used had to be as pure as possible, and was indispensable for the making of these pastes and their consistency. After being repeatedly washed to free them from the dust that had accumulated as a result of the grinding, the minute homogeneous grains that were to form the paste had to be used at once for the best results to be obtained. The slightest carelessness at any moment during the preparation was liable to result in muddied colouring, cracking, staining and porosity. The paste was left to dry and then fused by being fired in a wood or charcoal furnace. The Benedictine monk Theophilus (late 11th–early 12th centuries), author of the *Schedula diversarum artium*, a treatise on art techniques then in use, wrote that fusion was obtained in an earthenware vessel inside a protective perforated iron box, placed in a charcoal furnace.

The manufacture and application of the pastes, which took place in the goldsmith's workshop, required precise knowledge and great care. The final product had to have uniform thickness and as this was sometimes impossible to obtain by a single application and firing, a succession of superimposed layers was sometimes required.

All metals may be enamelled except phosphor-bronze and platinum. The enamel may be translucent or opaque, colourless or multi-coloured. Colouring is obtained by means of suitable metallic oxides which have been prepared by the same technique as that used for the pastes and added to the paste made for the colourless enamel. Enamelling may be *à jour*, i.e. transparent, or *à nuit*, i.e. applied on a thin plaque; the second type has always been the most widespread and covers the categories of *cloisonné*, *champlevé*, translucent enamels, and *émail des peintres*. In *cloisonné*, the enamel is poured into compartments (*cloisons*) formed by thin metal strips (called *corriolae* by Theophilus) which are shaped by pincers in order to follow the lines of the design, and then soldered on edge to the surface of the plate so as to form walls. The result is not so very different from that obtained in earlier times by inlaying cold enamels beside hard stones as, for instance, in the Egyptian jewels of the 12th and 13th dynasties (*c.* 2000 and 1660 BC). Moreover the setting of stones in compartments to trace the outlines of the pattern in early medieval enamelware resembles *cloisonné* in its effect. When we com-

pare the enamelling in the jewellery of the Dark Ages, the effect given, in all its barbaric splendour, resembles that produced by the use of flat, encrusted stones.

The technique of *cloisonné* predominated throughout the whole of the Middle Ages until the Romanesque period and was continued even later. In this technique it is more than probable that fusion was carried out simultaneously in the various compartments of the plaque. The monk Theophilus has left us a detailed description of the different phases in the preparation of the plaque and the washing to the final process, but he says nothing about the preparation of the pastes, only indicating where various coloured glasses may be obtained easily so that the enamel will not be *perspicax* but of a marble-like density as in the Roman pavement mosaics. Theophilus also made some mention of fashions in specific objects: for example, he wrote that enamel should be used for golden chalices in which the richness of the encrusted pearls and gems might be heightened by the addition of a band around the rim.

The name *champlevé* enamel, which was principally developed in the 12th and 13th centuries, is derived from the method of digging out from the metal a number of compartments for the pattern, leaving raised dividing strips. The enamels were set in the appropriate cavities of the plaque, either during the fusion of the plate or by hammering, or incision by means of a suitable tool. In the last case, the grooves and furrows made in the plaque facilitated the application of the enamel.

Still another variety is translucent enamel. By working on a gold or silver plate, in very light relief (*basse-taille*) with burin and chisel, not only was it possible to obtain various degrees of chromatic intensity, according to the depth of the compartments and consequently of the enamel, but it was also possible to exploit the shininess of the precious metal by graining, arabesque patterns and guilloches. Whereas *champlevé* with opaque enamels required deeper incisions so that the underlying metal would be hidden from view, the 'skin' of translucent enamels could be extremely thin. The technique was widely used for Gothic goldsmith's work and jewellery, especially in France and Siena.

Enamelling, from the Gothic period onwards, was applied even to statuettes in the round but presented various difficulties according to the relief of the shapes to which it was to adhere, in view of its tendency to trickle downwards. For this reason it was necessary to apply the enamel partially and in successive stages in the most difficult cases.

These various techniques were sometimes combined in the same work. Limoges enamels, worked in *champlevé*, have some parts worked in repoussé relief, i.e., with the metallic plate being shaped with hammers and punches. Both opaque and translucent enamels could be used in the same work.

In the 15th and 16th centuries another technique, particularly rich in new expressive possibilities, appeared contemporaneously in Italy and at Limoges. This was enamel painted on plaques (*émail des peintres*),

nearly always opaque, to cover the underlying metal from view. In France, at the same time, the technique of chiaroscuro enamel with white figures on a black ground (grisaille) became widespread. The more numerous the superimposition of white layers, the better the relief effect obtained.

Painted enamel required an even more delicate technique, both in the preparation of the copper plate and the pastes, and in the use of the colours. To avoid the metal buckling during the firing, convex sheets were used and both sides given a layer of enamel (counter-enamel). After the pattern had been drawn, the pastes were applied with spatulas, paint brushes and pen nibs, either directly on the metal or after a coat of opaque enamel had first been applied as a supporting base. Since the various colours required a different, even if minimum, degree of fusion and therefore a different timing for application, artists began to paint the various areas in black, blue and green which they then fired. They then made successive use of other colours which needed less time for firing (white for instance), pink being painted and fired the last of all since it required the lowest temperature. In order to make the colours brighter and more luminous, they were enriched with gold illumination, with thin lines or points made with a paint brush, or else with extremely thin foils of gold or silver (*paillons*) which were then covered with translucent enamel to obtain the greatest brilliance. When the work was finished, with as many as twenty firings

sometimes being needed, everything was covered with a colourless enamel and the final firing had to be as rapid as possible so that the enamels would not become mixed. Even the mistake of one second was enough to ruin the patient work of months.

A jour enamelling, which was less frequently used, was mainly practised between the 14th and 16th centuries. The rules that were followed for the process have been described by Benvenuto Cellini in his *Trattato dell' Oreficeria* (Chapter III). Since the beauty of this kind of enamel is revealed in its transparency, the enamels used were translucent. And since the enamel was to be attached only along the edges, when it was being fused it was placed on metal supports secured to metal bases of suitable size with gum mastic or wax along the dividing lines, which could then be removed by various means after the firing.

Quite often the enamels were likely to crack during firing as a result of even the slightest dilation of the metal. Moreover the metallic oxides were likely to dissolve and thus modify the original colour to some degree, especially in the case of copper and silver although not of gold. When the enamel was translucent these changes were only too obvious and as a counteracting measure an underlying opaque layer of enamel was applied for protection.

We still know what enamel techniques were in the mid 16th century thanks to the detailed rules of the art that Benvenuto Cellini described in his *Trattato*

dell' Oreficeria. The art had 'gently flowered' in Florence 'so that not a few of the craftsmen of Flanders and France, where it was greatly in use, acquired their craft through the observation of the enamel work of our own craftsmen'.

'First you make a plate either of gold or silver and of the size and shape that your work is to be. Then you prepare a composition of hard resin and brick ground very fine ... which you then put upon a board great or small in accordance with the size of your work. . . . Then you draw an outline with your compasses in depth rather less than a knife back and, this done, grind your plate near this outline with the aid of a four-cornered chisel to the depth which the enamel is to be, and this you must do very carefully. After this you can grave in intaglio on your plate anything that your heart delights in, figures, animals, foliage, all cut with great care with burin and chisel. A bas-relief has to be made about the depth of two ordinary sheets of paper, cut with finely pointed tools, especially in the outlines. But if your figures are clothed with drapery, know that these folds will well express the drapery if sharply drawn and well projecting. It is all a question of how deeply your work is engraved, and the little folds and flowerets that you figure on the larger folds may go to represent damask. The more care you put into this part of the work, the less likely the enamel will be to crack and peel off hereafter, and the more carefully you execute the intaglio the more beautiful your work will be in the end. But do not

imagine that by touching up the surface of your work with punches and hammer it will gain anything in the relief, for the enamels will either not stick at all, or the surface that you are enamelling will still appear rough.'

'Enamelling is just the same as painting,' declared Cellini, 'and that is why you should have your enamels and pastes well ordered and prepared; for, as gold-smiths are commonly wont to say, "enamel should be fine and niello should be coarse".' Once the enamels have been pounded and ground in a mortar under water and 'your enamels are all well washed in this way, you should put each in its little jar of glass-ware or maiolica but take great care lest your water dry up. . . . Before the goldsmith makes ready to enamel the work, you must take a plate of gold or silver and on this put all the different colours you intend to use.' To test the colours and ensure successful firing, Cellini says, 'the preliminaries done, you may begin to enamel objects in low relief, always taking care to keep your jars covered. . . . Take your enamels with a little copper palette knife and spread them out little by little very carefully over your bas-relief, putting on any colour you like, be it flesh-colour, red, peacock blue, tawny, azure, grey or capucin colour, for that is what one of the colours is called. One colour I forgot, and that was "Aqua Marina", a most beautiful colour which may be used for gold as well as for silver. I do not mention white and turquoise blue enamels because these are not suitable for transparent enam-

els. When you first apply the enamel, you must lay on the first coat very thinly and with great care for you must put each colour very neatly in its place, as in a miniature, so that one colour will not run into another.' After the firing of this first coat 'apply the second coat of enamel in the same way as the first . . . and then put it back in the furnace. . . . This done, take some of your *frassinelle* [used for sharpening the points of metalworking instruments] and with them smooth your work over until you see it transparent enough and get the right effect, and finally polish with tripoli [rottenstone]. This method of enamelling requires hand polishing and it is both the safest and most beautiful. The other way of cleaning is as follows: when the enamel is covered with the above-mentioned stones and thinned and well polished with fresh running water, it is put back in the furnace, but you must take care lest the enamels run or become pale.'

Two of the most ancient examples of enamel art are the Mycenaean jewellery found in the tomb of Kouklia in Cyprus and the pectoral of Amenemhet III (1840–1792 BC) in the Cairo Museum, the enamels in both cases being set into compartments when cold. On the other hand in an Egyptian-style jewel of the 14th–13th centuries BC in the British Museum, glass pastes were fused in firing into compartments, the different colours being separated by wire threads which give the enamels a gem-like effect. But in the most ancient surviving examples of enamel art, what

the craftsmen were doing was to produce artificial gems rather than enamel in the sense we know it, with thin coats applied in layers on a metallic base.

In classical Greece enamel was fused between thin strips of metal on to plaques of gold, whereas the Romans used *champlevé* and *cloisonné* techniques on bronze plaques. But the enamel art of medieval western Europe was fundamentally derived from Byzantine enamel art, itself a product of Greek and Roman traditions.

In Byzantium, between the 7th and 12th centuries AD, enamel art had reached a high degree of technical refinement and expressiveness, for it was encouraged by sculptors and goldsmiths and a cultural environment that saw miniatures and paintings attain their highest level. Byzantine enamels reproduced not only the subject-matter and style of paintings but even their sumptuous colouring. One of the many Byzantine masterpieces to be seen in the treasury of S. Marco in Venice is an 11th-century *cloisonné* missal binding with Christ on the Cross flanked by the Madonna and St John and the sun and the moon in the upper register. Such subject-matter and colouring were by no means unusual in various Byzantine works of the same period and they were later taken as models for Crucifixion scenes in Limoges enamel art.

The enamels of Byzantium were among the many products of this ceremonious and refined civilisation which showed equal enthusiasm for magnificent private and religious architecture, luxury in dress

and jewellery, finely worked table-ware and richly embellished saddlery. For the artists of the time the splendour of the external world was sufficient reason in itself to serve as a model for imitation in every branch of art and living.

From Byzantium, small medallions, rectangular plaques and golden caskets containing relics of the True Cross came to western Europe, brought by merchants, pilgrims and crusaders, or else sent as presents by the emperors. Even more arrived as a result of the sack of Constantinople in 1204 at the end of the Fourth Crusade, including the sections of the golden altarpiece (Pala d'Oro) which is the pride of S. Marco in Venice.

Byzantine enamels were imitated everywhere—in Lombardy during the Carolingian and Ottonian periods, in Fatimid Egypt, Umayyad Spain, and in Russia. Byzantine goldsmiths were invited to Italy in the 11th century by Desiderio, abbot of Monte Cassino, later Pope Victor III; later, in southern Italy and Sicily, local goldsmiths worked side by side with Byzantine and Arab jewellers, making enamels in the style of Byzantium.

In the 12th and 13th centuries enamel was mostly used for embellishing various items of church plate and vestments, such as chalices, pyxes, reliquaries, crosses, altars, croziers and the bindings of sacred books. In some regions practically every item of church equipment was enamelled. At Limoges even incense burners were enamelled (Cluny Museum,

Paris; Dijon Museum; Musée de Picardie, Amiens; Musée Bargoin, Clermont Ferrand), as well as censers (Cluny Museum, Paris; Museo Civico, Turin), pedestals of crucifixes (Sto Sepolcro, Barletta), candelabra (Vatican Museum, Rome; Dijon Museum; Museo Civico, Turin) and monstrances (Limoges Museum). The result was that the altar and the entire church itself would gleam with brilliant colours rivalling those of the paintings, liturgical hangings and vestments, all combining to make a joyous feast of colour under the 'sky' of the painted ciborium—as in Spain—or the frescoed apses where the same themes—especially Christ in Majesty—would be repeated in the enamel designs.

Enamel was also frequently used in domestic items although few such objects have remained in existence. Enamel decoration has survived longer in such objects of household use as caskets, first used to contain private possessions and then later used as reliquaries, with medallion decorations and enamelled corner-pieces set on the wood and resembling the reliquaries made by Byzantine goldsmiths and craftsmen of 12th-century Europe. Among such pieces, we should mention the exquisite early 13th-century strong-box (private collection, Milan) which came from a Limoges workshop and was made to contain part of the jewel collection of Cardinal Guala Bichieri, the founder of the abbey of S. Andrea at Vercelli. The corners and lower rims are enamelled, the lid decorated with medallions featuring figures of monsters

and fighting beasts in relief and openwork, sur-
rounded by a cornice of circular bands of decoration
on an enamel base, and the sides are covered with
hunting scenes which seem to anticipate the courtly
scenes that were such a frequent feature of Gothic
art. Other important caskets include that of the
Blessed Amedeus of Savoy of which only the bosses,
decorated with profane scenes and coats of arms,
worked at Limoges in the early 13th century, have
survived (private collection, Turin); the chest in the
treasury of the cathedral of Aachen, originally owned
by the counts of Limoges and then by Richard of
Cornwall; the casket with female figures and hunting
scenes, dating from the second half of the 13th century,
made at Limoges and now in the Museo Leone at
Vercelli; and lastly the casket of St Louis (Louvre,
Paris).

Another domestic utensil was the *gemellion*, a
circular plate or basin which could also be used in
church, although those that were so used—like most
that have survived—could sometimes be decorated
with secular scenes. Similarly beakers that were used
to contain holy water for religious ceremonies could
also serve for domestic purposes.

Enamel was also used in a few exceptional cases for
decorating tomb slabs like that of Geoffrey Planta-
genet (Le Mans Museum), made at Limoges in about
1151–1160, or for *appliques* for gilt bronze tomb slabs
like those of the counts of Champagne, Henry II
(died 1181) and Theobald (died 1202). Originally

in Troyes cathedral, they were destroyed during the French Revolution and all that has remained are the wonderfully decorated nineteen semicircular plaques now in the cathedral treasury, featuring Biblical scenes and similar in spirit to the art of the Mosan school.

The great popularity of enamel and the fact that it was used in Byzantine and Dark Age jewellery would suggest that it continued to feature largely in jewel-making in the early Middle Ages. Little has survived to the present day, most of it being cere- monial apparel, mostly for bishops' vestments. Of the secular jewellery that remains, we should mention the clasp of the Empress Gisela, wife of Konrad II (Altertumsmuseum, Mainz), in which orientalising tendencies may be seen in the working of the *cloisonné* and the stylised eagle.

One of the few 'political' themes found in enamel art of this period is the scene of the coronation of Roger II of Sicily by St Nicholas in the ciborium plaque now in the church of S. Nicola at Bari, a southern Italian work probably dating from the 12th century. Another unusual use of enamel was in vestments where it was combined with embroidery work as in the great mantle of Roger II (Schatz- kammer, Vienna), made in the monastery of Palermo in 1133–1134. As there was an increase in the '*multi- formis picturae varietas*', i.e. the richness and brilliant colouring of the cloth and the embroidery, gold- smiths also took part in the work. The mantle was

held in place by square enamelled clasps, the enamels being set within the embroidery work of small pearls along the hems. Other enamels were used for gloves, under-tunics, caps and sandals, all part of the complete ceremonial attire. Enamel was also used in combination with pearls, gold plaques and gems for the sword and scabbard. Consequently we are now better able to understand a passage from Ugo Falcando's *De calamitatibus regni Siciliae* in which the writer mentions similar embroidery work (such as the mantle just described and the coif of the emperor Frederick II's wife Costanza now in Palermo cathedral), adding that 'intact pearls were set between gold thread or else bored and tied with elegance and skill in patterns to heighten the beauty of the painted parts', the 'painted parts' being the enamels.

In Byzantine jewellery from earliest times, as in Carolingian and Ottonian jewellery, enamel was used with gems to form exquisite patterns in which the main function of the stones or cameos was to underline the overall pattern. In the Romanesque period, although enamel was still used together with gems for certain objects, it became more frequently used on its own but in some cases it took second place to some more precious material, although copper was generally used for the supporting base. As a consequence, while enamel techniques were changing from *cloisonné* to *champlevé* in the early 12th century, enamel took over the important role formerly played by precious metals and stones, both because of its own

intrinsic beauty and because of its enormous chromatic possibilities with the colours heightened by the gilding of the unenamelled copper parts.

French and German works of the 12th century all witness to the new lively Romanesque style and culture. Experts generally agree on the priority of the German works which kept their Romanesque characteristics longer than those from French workshops, but proof is still lacking. The tomb slab of Geoffrey Plantagenet, which was made at Limoges, may be dated between 1151 and 1160 and as it is earlier in style to many works of the Rhenish (from the Rhine area) and Mosan (from the Meuse area) schools there is no evidence to support the view that the German craftsmen were the first to introduce *champlevé* techniques—whose origins are still a matter for controversy.

What is certain, however, is that from the great series of enamels from the portable altar of Paderborn cathedral and the sumptuous binding with the *Christ in Majesty* from the Maastricht treasury, a *cloisonné* work of about 1100, to the works of the great artists of the end of the century such as Godefroid de Huy, Nicolas of Verdun and Eilbertus of Cologne, the Rhenish and Mosan enamels were all the creations of brilliant schools and artistic geniuses who expressed their passionate creative personalities in sober, strong designs and intense or even contrasting combinations of colours.

In the first thirty years of the 12th century a new

school arose to rival the artistic centres of the Meuse region and the lower Rhine, themselves still favoured by the ease of communication that the network of rivers offered. This was the school of Limoges, the Roman *Augustoritum*, which had been the capital of a viscounty under the Merovingians and Carolingians before becoming the capital of the Limousin during the Middle Ages. The region contained many great abbeys, such as those of St Martial at Limoges, Solignac, Grandmont and Ste Foy at Conques, which were all favourable to the rise and growth of the new workshops since, like the German centres of enamel manufacture, the region was rich in precious metal deposits.

Frequent exchanges soon took place between the various abbeys. Particularly famous were the cordial relations through letters, exchanges of relics and visits between the abbey of Solignac (Limoges) and that of Stavelot (Meuse) which had been founded by Remacle, the abbot of Solignac. A body of traditions and accounts of voyages made by the Limousin monks to Cologne are evidence of the close links existing with the cultural centres of the Rhine. There is no doubt that the Limousin, Rhenish and Mosan enamels revived the splendour, perfection and beauty of Byzantine enamel art in 12th- and 13th-century western Europe and won similar widespread popularity. With the possible exception of 13th-century France and Siena, no other school or period ever produced works of greater beauty and enchantment.

A distinguishing feature of these schools was the close relationship between the enamels and miniatures of the time in style, patterns and subject-matter. Although such relationships may be easily explained by the fact that enamel workshops and the miniaturists were in the same monasteries, the fact remains that enamel art was often directly inspired by miniature painting, particularly in the composition of the scenes depicted and in background treatment with interlace patterns and foliage motifs, and the rosettes and floral decorations of later times. An important example illustrating this close link between enamel art and miniature painting is the triptych attributed to Godefroid's workshop, dating from 1150 (Victoria and Albert Museum, London), especially in the framing of the scenes on the centre panel and the rhomboid enclosed within a square linked to four circles—a theme that was taken up again with spectacular effects inside the triptych wings.

It should also be pointed out that certain stylised images of Christ in Majesty, flanked by symbols of the evangelists, and certain tragically expressed scenes of martyrdom or the Crucifixion in these enamels have a breadth and spaciousness of treatment and a rhythm of composition that bring them very near in effect to large-scale fresco paintings of the time and the colours and patterns of altarpieces, while the way the colours of the gems and enamels are compartmented is reminiscent of contemporary work by the glass-maker, then creating exquisite stained glass

windows for the cathedrals of central Europe. Moreover, when the Rhenish craftsmen of the 12th century made enamelled plaques for crucifixes, they frequently divided the colours, even those of equal tonal value, into compartments by a technique that corresponded exactly to that used by the stained glass artists who divided large panes into sections by means of lead strips.

The enamelled plaques were often fixed on to perishable materials, such as wood, as in the case of caskets, reliquaries and book-bindings, which have since disappeared. But being created separately as objects of aesthetic and expressive significance in their own right—like the Byzantine enamels—they have lost nothing of their beauty and meaning and have kept their value and individuality even when detached from the context of the object for which they were made. But, as is only natural, in order to appreciate these enamels fully, we should be able to consider the object in its entirety, the way in which the decorative elements were designed in relation to its form, and the composition of the narrative scenes.

Reliquaries were usually designed as rectangular caskets topped by a lid with twin sloping sides surmounted by a copper crest in openwork, with the various figurative and narrative sections of the design corresponding to the geometrical surfaces. One of the main sides would usually be covered with a spacious treatment of the main theme, generally a *Crucifixion* with the figure of Christ flanked by saints.

The sloping lid would feature a *Christ in Majesty* while the back and ends would depict episodes from the life of the saint whose relics were contained in the casket. But the main side could also be decorated with scenes from saints' lives, especially St Martial and St Valeria, the patron saints of the Limousin, or St Thomas à Becket who was venerated throughout 13th-century France with many Limoges reliquaries devoted to him.

The most elaborate kind of reliquary was that with a cross-piece resembling the transept of a Gothic church. Two beautiful examples of this kind are the late 13th-century caskets in Agrigento cathedral which are probably the work of the same artist. This type of reliquary was also popular in Spain, a famous example being the 'ark of the enamels' in the collegiate church of S. Isidoro at León.

There was often a close relationship between the geometric design of the object and the geometric distribution of the enamelled plaques over the surface, the overall effect heightened by their brilliant colouring. The square, almost cubic, shapes of some ciboria, with pyramidal lids like the one in the Louvre, were stressed by the enamel decoration as in the lid of the 'cubic' ciborium in the church of Sto Sepolcro at Barletta which has vividly designed corner buttresses soaring up to connect with the pointed cusp.

Enamelled plaques for book-bindings were always rectangular in shape. The themes that were most often treated within the framing, which might be

enamelled all over with various decorative motifs, or only in the corners, were *Christ in Majesty* or the *Crucifixion*. For the *Crucifixion*, the scene was divided into four sections by the arms and uprights of the Cross, the two lower sections being reserved for the grieving figures of Mary and St John, the two upper-most sections for personifications of the sun and the moon enclosed in tondos.

Various such bindings have survived in works that are perfect also in the unity of the overall design. A great many examples of the *Christ in Majesty* may still be seen in museums (Louvre and Cluny Museum, Paris; Metropolitan Museum, New York; Plandiura Collection, Barcelona; Kofler-Truninger Collection, Lucerne; Lecce Museum; Museo Civico, Turin). They consist of a mandorla extending over almost the whole surface of the plaque and containing the figure of Christ with the corners reserved for the symbols of the evangelists which assume a distinct emblematic beauty due either to the decorative development of the freely lengthened wings or to the abstraction of the colouring.

The portable altars of French or German manu-facture were basically casket-reliquaries destined for celebration of the mass in wartime or during crusades and even during hunting expeditions. They were designed as miniature versions of the altarpiece in churches and were covered by a flat slab that projected over the sides rather like an altar table. A large number of such altarpieces have survived in Germany and

Austria (Vienna, Bamberg, Trier and Siegburg), a lesser number in France and only a few in Italy, the most important being the one in Agrigento cathedral, dating from the early 12th century, and another in Cividale Museum in the province of Friuli. Even in the altarpieces, the figure decoration was influenced by the geometrical shape in which it was set. The scenes would often be set within arcades running around the four sides as a kind of flat cornice for the consecrated altar table which was generally made out of a slab of precious stone such as agate, onyx, jasper, porphyry or oriental alabaster.

Other enamels, like the frontals covering the reverse side of the altar (two of the most important being found in Spain in the churches of S. Domingo at Silos and S. Miguel de Excelsis at Orense, dating from the late 12th century), repeated the shapes of the more usual tempera-painted frontals, with the figures of Christ or Mary in the centre, flanked by saints and set within arched framing.

But if one is to have a clearer idea of styles and fashions in Romanesque enamel art, it should be remembered that it was quite common for goldsmiths to make use of several different techniques for the same work. Artists of the Limoges school, like those of the Meuse and Rhine regions, made statuettes in the round with some parts worked in high relief and others in openwork by fusion and careful finishing with burin and chisel and combined them with enamel surfaces. In the base of the crucifix of St Bertin (abbey

museum, St Omer), a work of the Mosan school dating from about 1170, tiny figures of the evangelists are set upon the four feet of the Cross almost as buttresses for the hemispherical calotte, covered with enamels within a lunette design, topped by the bronze figures of the evangelical symbols and the enamelled plinth of the Cross. The successful unity of the overall design is thus obtained by means of this vast counterpoint of curves and spaces.

One can now understand how the splendid forms of the objects made at Limoges had an aesthetic value of their own which could be even more important than the enamelled decoration and the mounting of the gems. To take one example, in certain pyxes of 'double bubble' shape consisting of a bowl and lid, the form of the pyx, the relief and incised parts, the encrusted gems and the enamelled surfaces all contribute to the overall aesthetic unity of the object. No one element dominates the others and all have an independent but harmonious expressive value, as in the pyx signed 'G. Alpais' in the Louvre (Plate 26). The pyx is decorated with *cabochons* at the intersections of the network of lozenge patterns containing figures of saints and angels, and stands on an openwork base with figures set between interlace motifs derived from Sassanian art.

In the magnificent series of bishops' croziers which were sometimes embellished by the addition of tiny figures and groups in the round, harmoniously set within the curve of the staff (*St Michael and the Dragon*

was one particularly popular theme), enamel was added to embellish a work that was already perfect in itself and was used purely as decoration, underlining certain parts, and as the enamel was often monochrome the colour used was turquoise blue.

In the earliest *champlevé* enamels on copper plaques, especially those from the Rhine and Meuse regions, when the artists incised the plaque to hold the enamel —especially for key-pattern motifs—they used an imitation of the *cloisonné* technique which was already widely diffused in those regions by the end of the 1st millennium AD. Small copper plaques were treated first and then placed on caskets; the enamel was then spread over the entire surface and, once sufficient technical progress had been made, was even used to decorate objects with parts in high relief or curved surfaces like croziers, candle holders, pyxes shaped like doves and worked in relief, and circular pyxes with high conical lids.

In cast bronze statuettes (the *Madonna and Child* or *Crucifixion* being the most frequent themes, although angels were also used for reliquaries and figures of saints as in the antependium of St Peter's in the Vatican) enamel was used to emphasise certain details such as the eyes or to imitate precious stones set in the hems of costumes. In these works, the vitreous skin was made to adhere to curved surfaces by the use of a technique that was to be brought to perfection later in the 14th century.

To have a complete picture of fashions in enamel

and art, it should be remembered that in almost all the works mentioned, the enamel was spread over the entire surface of the object. The simplest kinds of Limousin reliquaries of the 12th and 13th centuries were often decorated with scenes on every side, even on the underside, with rosettes within linking circles or lozenges. In other objects, especially those of great importance, even the interior was enamelled, like the ciborium signed 'G. Alpais' whose interior is decorated with an angel surrounded by an inscription including the artist's name. The taste of the time was for abundant decoration. For *Crucifixions* the figure of Christ would be in enamelled *applique*, set on a Cross covered with vivid coloured damask roses, as in the crucified Christ wearing a *kolobion,* made in Germany during the late 12th or early 13th centuries (Museo d'Arte de Cataluña, Barcelona). In the mid 13th century, the centres of the Meuse region (Huy, Maastricht, Liège) were becoming increasingly important as centres of enamelled jewel manufacture thanks to the energetic encouragement of such powerful and distinguished customers as the abbots of Stavelot, St Denis, St Bertin, and the centres of the Rhine regions headed by Cologne, which inspired other centres of enamel art between Westphalia and Lower Saxony.

Both regions were receiving Byzantine enamel works which were already being imitated as early as 1150, while Byzantine portable sculptures (ivories, bronzes, jewellery) were also being widely diffused

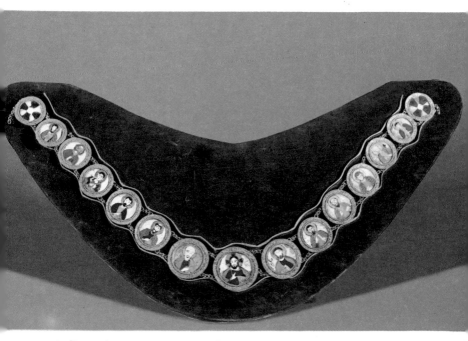

1. Byzantine art. 6th century. Gold medallions with *cloisonné* enamels. National Gallery of Fine Arts, Washington.

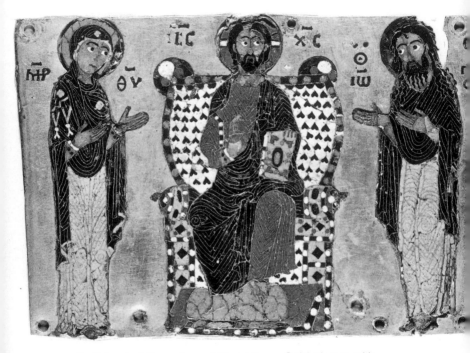

2. School of Byzantium. 11th century. Gold plaque with
cloisonné enamel figures of Christ enthroned between Mary
and St John. Vatican Museum, Rome.

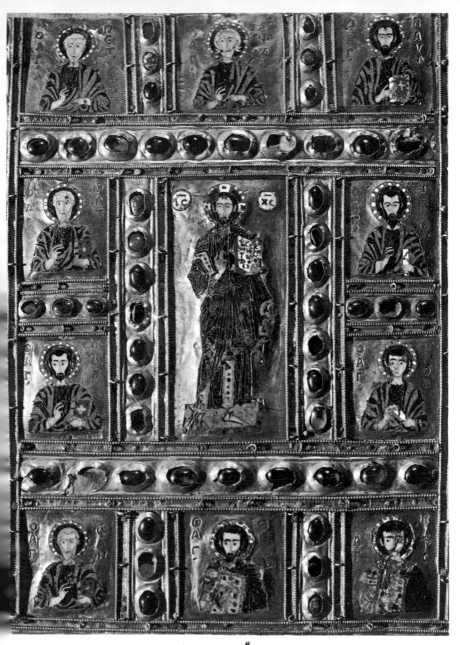

3. Byzantine art. 12th century. Book-binding in silver gilt, gems and *cloisonné* enamels. Biblioteca Marciana, Venice.

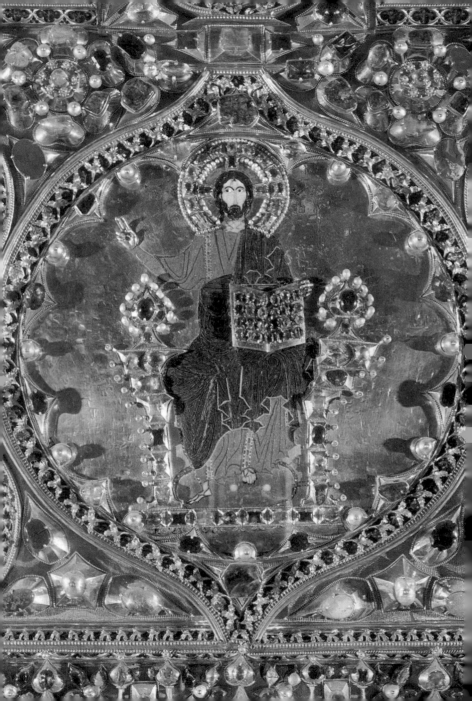

4. Byzantine art. Detail of the centre panel of the 'Pala d'Oro'. S. Marco, Venice.

5. Nicolas of Verdun (late 12th-early 13th centuries). Detail of the enamelled gold altarpiece in Klosterneuburg abbey, near Vienna.

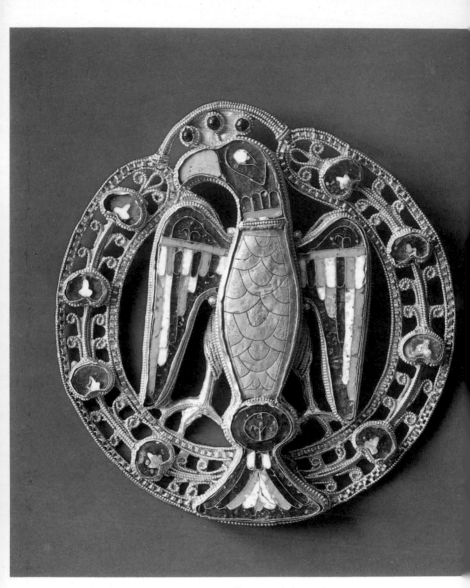

6. Ottonian art. 11th century. Openwork brooch.
Altertumsmuseum, Mainz.

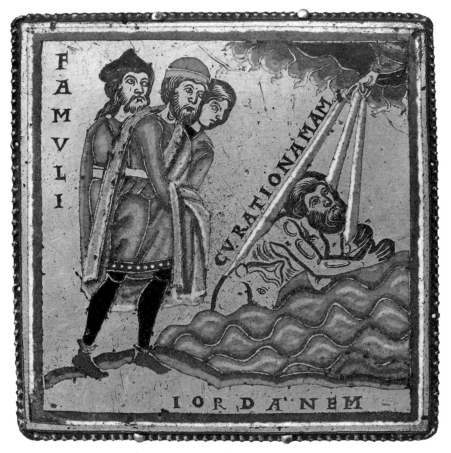

7. Godefroid de Huy (second half of the 12th century). *The Healing of Naaman the Leper.* Victoria and Albert Museum, London.

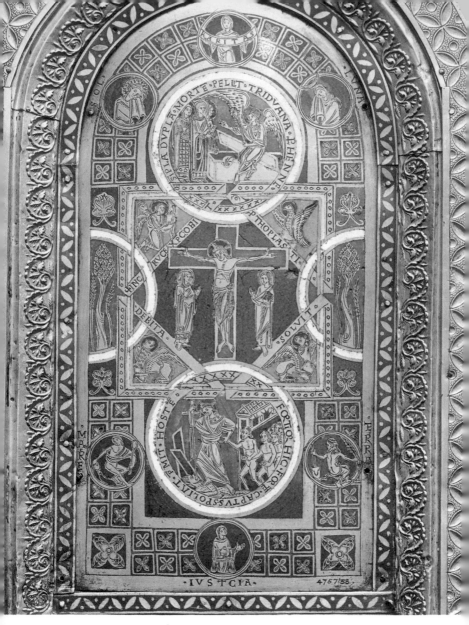

8. Workshop of Godefroid de Huy. Centre panel of a triptych
with scenes of the Crucifixion and the Passion. Victoria and
Albert Museum, London.

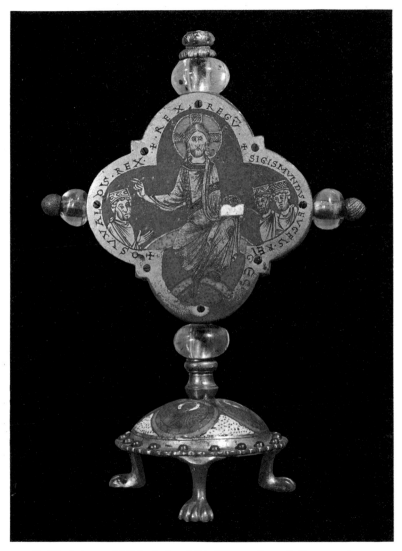

9. Workshop at Hildesheim. Mid 12th century. Reliquary of Henry II with *champlevé* enamels. Louvre, Paris.

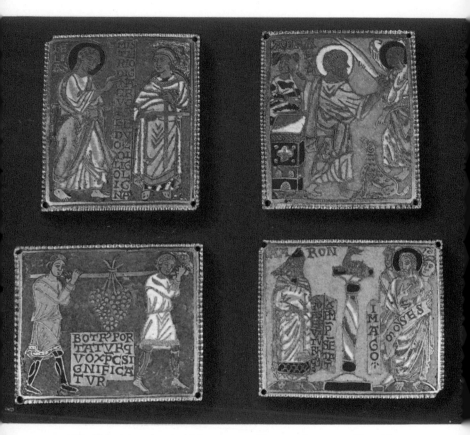

10. Rhenish school. 12th century. Plaques for a crucifix with Biblical scenes. Bargello Museum, Florence.

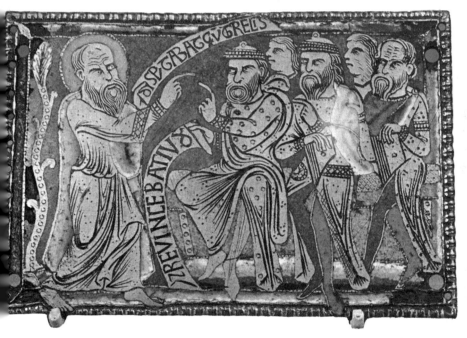

11. English school. Late 12th century. Plaque. *St Paul disputing with the Greeks and Jews.* Victoria and Albert Museum, London.

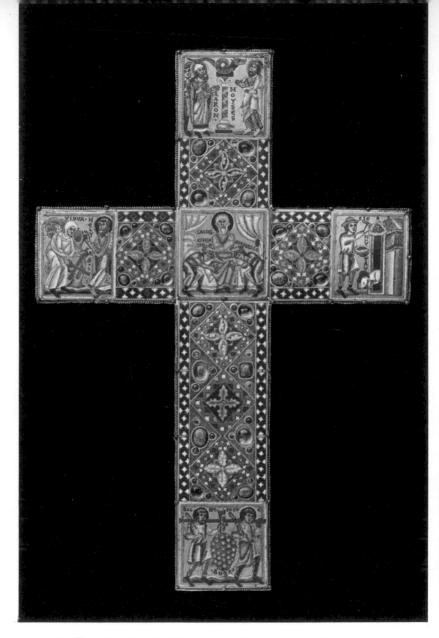

12. Rhenish school. 12th century. Enamelled crucifix decorated with Biblical scenes. Victoria and Albert Museum, London.

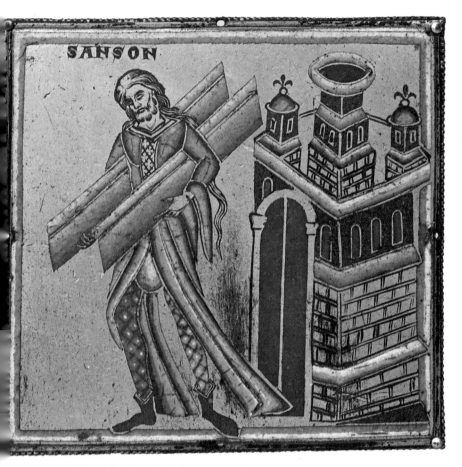

13. Rhenish school. 12th century. Plaque. *Samson carrying off the Gates of Gaza*. Victoria and Albert Museum, London.

14. Rhenish school. 13th century. Plaque for a book-binding with Christ enthroned within a mandorla. Germanisches Nationalmuseum, Nuremberg.

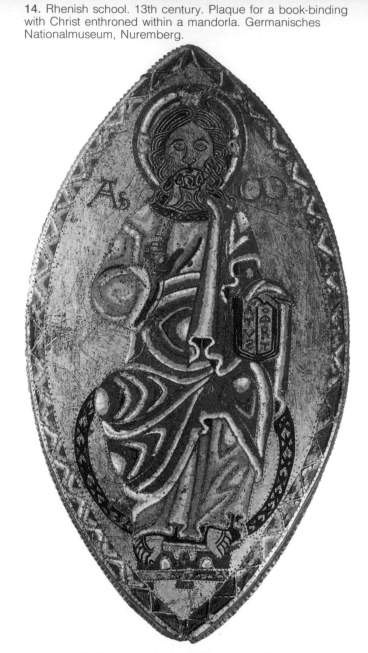

15. Limoges school. 12th century. Plaque from the tomb of Geoffrey Plantagenet. Musée Tessé, Le Mans.

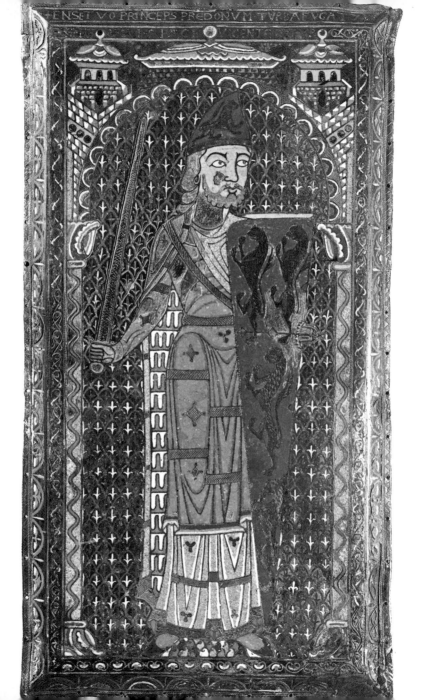

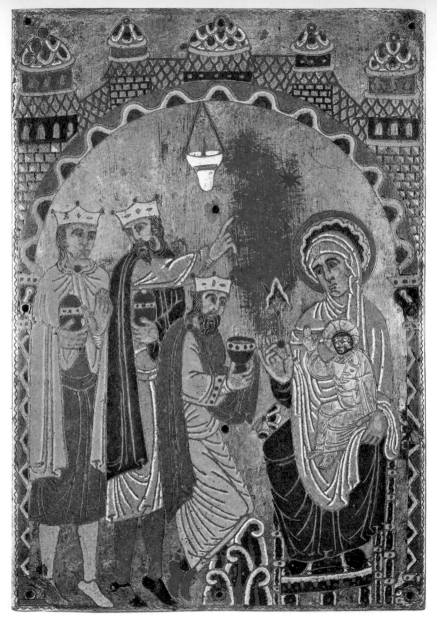

16. Limoges school. 12th century. Plaque. *Adoration of the Magi.* Cluny Museum, Paris.

and influencing the sculpture of the Mosan school. The styles and forms of Byzantine sculptures inspired the forms, style and subject-matter of the triptychs of Godefroid de Huy, especially the one made for an abbot of Stavelot in about 1175 (Pierpont Morgan Library, New York), and the two in the Petit Palais at Paris. At the same time, the first individual artistic personalities made their appearance. Godefroid, who died in about 1175, was one of the greatest enamel artists of the Mosan school and was recorded as having travelled and worked a great deal 'for many kings'. Apart from the three triptychs, he has been convincingly identified as the artist of the bust-reliquary of St Alexander (Musée d'Art et d'Histoire, Brussels), the altar at Stavelot, the reliquary of St Mangold and St Domitian dating from 1173 (Huy collegiate church), the arm-reliquary of St Jacques (now at Binche), the Cleveland reliquary, the portable altar in the treasury at Tongres, and the Solières crucifix.

As the palette of the enamel artist had now become extremely rich, the colours acquired the mineral tones of precious stones, and artists sought for more expressive and varied effects. For the pedestal of the St Bertin crucifix, four kinds of blue, three kinds of green, black, red, violet, turquoise and yellow are all used in a feast of colour, and there was an evident attempt to create a plastic effect in the way the lighter colours were reserved for the relief parts. Towards 1180, another artist of the Mosan school came into

prominence. He was Nicolas of Verdun, a dazzlingly accomplished goldsmith of great refinement with pupils and followers who continued to use his techniques and formulas. The pulpit of the abbey church of Klosterneuburg near Vienna (1181), transformed into an altar triptych in 1330, was his first signed and dated work and one of the largest ever made in medieval Europe. Enamel was used on a monumental scale; the figures, the landscape and architectural parts of the fifty-one panels representing scenes from the Old and New Testaments were left in gold on a uniform blue enamel background, while the incised and hatched details were filled in with coloured enamel (mostly blue and red) by the use of a technique normally reserved for inlaid enamelwork. The panels were all extremely varied in design, and polychrome enamel was used as a contrast for the framing.

Nicolas' style was highly articulate. He combined exciting luminosity of colour, his dominant blue having an unprecedented metaphysical and timeless effect, with mastery of composition and design and a vigorous plastic sense that attained almost classical grandeur, and with a rhythmic linearism in the gestures and draperies that seemed to anticipate some later Gothic masterpieces. In the later works the enamel was given a complementary function within the confines of his characteristic blue backgrounds for the figures in relief and in the round. In this way sculpture and carving took precedence over the

enamel work as may be seen in the three Cologne reliquaries (St Annone at Siegburg; St Albinus in the church of Pantaleon; the Three Magi in the cathedral) and in his last dated work (1205), the reliquary of St Mary at Tournai.

Another product of the early Limousin school is the enamelled tomb plaque of Geoffrey Plantagenet, a work executed in a severely controlled style. It can easily stand comparison with the monumental character of Romanesque art and the expressive power of the works of the Mosan and Rhenish schools. The plaque bearing the family founder, represented alive and armed, is outstanding for its size ($24\frac{3}{4}$ in. × 13 in.) and the delicate beauty of its colouring: grey-pink, ochre, brown, for the flesh tints and the hair, lapis-lazuli blue for the shield and the helmet, with lighter colours (green, sky-blue, azure, white and yellow) predominating in the draperies and the architectural elements in the background. Later Limousin enamels also differed from their counterparts of the Rhenish and Mosan schools by the vivacity of their colouring as shown in this work, by the prevalence of blue and green, by the way yellows and greens were used to emphasise the folds of the draperies, and by the elegant patterns of the gilt copper outlines of the long drooping figures.

It is very often difficult to classify Limousin *champlevé* enamels on the basis of style and to assign the extremely large production of the school to different artists. Consequently the most usual method

of classification is to divide them into two groups, rather like the division of Greek pottery into black figure and red figure categories. In the first group the figures are enamelled on a background of gilt copper; in the second, the figures are left in metal on an enamelled background. A later system for classifying works belonging to the first group takes account of the different ways in which the metal was worked, objects with uniform copper backgrounds being dated from the last quarter of the 12th century, vermiculated backgrounds from the late 12th and early 13th centuries, and guilloche backgrounds—in which such motifs as rosettes, stars, interlace motifs and foliage were introduced—to about the middle of the 13th century. Incised backgrounds, which had the advantage of allowing the gilding to be applied more securely, added to the splendour of the finished object.

In the first group the metal figure-work and the enamelling were on a single surface, but in the second group, which was already making its appearance in the early 13th century, the figures were fused, chiselled, and gilded and finally set in relief on the surface of the enamel. The relief parts might be only the head (casket of the 14th century, Bargello Museum, Florence) or the entire body (casket of St Faustus, 14th century, Cluny Museum, Paris), and they were often modelled with great sensitivity, as in the 13th-century *Madonna and Child* in Dijon Museum. This work is a true piece of sculpture in its own right, and the way in which the hieratic monumentality of

the frontal image is softened by the lengthening of the figures and the lively linear flow of the drapery folds brings the work into the mainstream of contemporary Gothic sculpture.

But the greatest and most characteristic beauty of these works lies in their colour. In contrast to the vivid and sometimes violent colouring of Rhenish and Mosan enamels, any harshness or contrast in the Limousin enamels is softened by more harmonious, elegant and graceful colour combinations, even though there is still sometimes a certain hardness in the use of cold greens and blues next to the white. Whereas in 12th-century works the different colour areas were divided tonally, groupings of graded colour tones were already being used as early as the second half of the century, perhaps as a result of the influence of Godefroid's enamel work. The subtle folds of the draperies were no longer outlined by a simple gold line; although the artists may not exactly have been trying for sculptural effects, they were at least trying to produce a kind of shot-silk effect and a richer colour scheme. This may be seen from the way a dark blue mantle had turquoise tints in the folds, yellow-greens in the costumes, or light blues that verged on white in proximity to the golden portions, and in the way blue merged into the white outlines in many nimbuses, flower motifs and border decorations. Towards the end of the Romanesque period, as many as two, three or even four tones of the same colour would be found within a single nimbus.

In the early years of the 13th century at Limoges,

enamellists adopted a system of colour grading according to suitability for firing: black (or red), blue, green; black (or red), blue, white; green, turquoise, white. In the same period the figures were elongated in slow rhythmic undulating compositions as part of a well-balanced overall scheme with dark blue backgrounds—one of the great specialities of Limousin enamel art—patterned with highly coloured lozenges and rosettes or horizontal flat turquoise bands. Even when blue was the dominant colour some small part was always heightened in dark green or yellow.

The Limoges school was very prolific. Enamel works made their way throughout France and were also exported to English abbeys and cathedrals, where Mosan enamels were already known and appreciated and where important similar objects were also being made. They went to Germany, Poland, Sweden, Austria, Spain and Italy where their influence was appreciable and led to the rise of new centres of enamel manufacture.

The first of the new centres was Spain, where enamel had a robust style common to all Spanish Romanesque art, and where important works were made in the second half of the 12th century after the arrival of the splendid Limoges masterpieces. The Limoges altar frontal—transformed into an altarpiece in 1765 — of the church of S. Miguel de Excelsis in Navarre (a region that was not only near but also historically linked with southern France) and the frontal of the

abbey of S. Domingo de Silos (Museo Arqueológico, Burgos) are two of the greatest masterpieces of medieval enamel art. They were grandiose works which revived the splendour of the Carolingian altars and they were probably gifts from princes. The figures of Mary (S. Miguel de Excelsis) and Christ (S. Domingo de Silos) are set within mandorlas high in the centre of each frontal and are larger than the side figures of the saints in accordance with the hierarchical canons of medieval iconography. Both Christ and Mary are represented seated on highly coloured rainbows instead of thrones but have all the attributes of regal authority including cushions and footstools. The singular beauty of the heads, which are treated in relief and may be considered as works of sculpture in their own right, is in contrast to the beauty of the freely and vividly coloured enamel, while the draperies are embellished with running arabesque patterns along the borders, with colours combined to produce contrasting effects. The un-realistic rigid frontality of the figures, with the saints set in arched compartments, the linear stylisation, the vivid splendour of the spacious gold and coloured areas—perhaps a surviving trace of Byzantine in-fluences—heightened by encrusted crystal and gem *cabochons*, give these altarpieces an almost hypnoti-cally sublime quality which seems to set them apart in some supernaturally remote dimension.

The Limousin antependium in St Peter's, made in the time of Innocent III but now dismembered and

partially lost, must have had a similar beauty of design with the twelve apostles standing on each side of Christ between small enamel columns.

The creative vitality and the great receptivity of Limousin art was apparent from the way it absorbed influences from other cultures—Byzantine culture by way of Italy, the Mosan and Rhenish schools of art and the cultures of Moslem Spain, Asia Minor and Egypt.

But the use of decorative figures, which undoubtedly speeded up production and thus facilitated exports, also led to a wearisome repetition of artistic formulas. Backgrounds showed an increasing use of the blue and were often decorated with polychrome tendrils and floral motifs (blue and white, red and yellow, green and yellow) or copper bands terminated by enamelled roses. At the end of the 14th century, because of the great number of commissions, and also, perhaps, because other regions and workshops had begun to produce Limoges ware, Limoges enamel manufacture practically became a mass production industry. Decoration became repetitive and monotonous, colours changed in the firing, figures were always executed in relief and lost what had formerly been their most original characteristic— an imaginative combination of figures and background on a single surface with delicate incised outlines.

In the 14th century kings and dukes, princesses and noble ladies, members of both the new and the

old aristocracies, the popes at Avignon and prelates everywhere were eager for the new, highly refined and graceful Gothic fashions in textiles, clothing, furniture and interior decoration of palaces and castles. This privileged society was always eager for splendid new jewels, belts, rings, necklaces, clasps and precious table-ware and it was this enthusiastic demand that explains the heraldic splendour of the objects of the time and why goldsmiths came to live at the courts. Apart from Avignon, where goldsmiths from Siena were working, and Burgundy, where gilt enamel techniques were adopted, Paris was an important manufacturing centre. For more than a century the many goldsmiths working at Paris, often known to us by name, made use of translucent enamel combined with silver and gold, and created marvellous objects like the beaker made between 1330 and 1340 (National Museum, Copenhagen). At the same time there was a revival of the fashion for *cloisonné* enamels in small openwork plaques, which gave the effect of tiny stained glass windows. Enamelled objects were made of precious materials instead of copper; their growing popularity was borne out by the fact that in 1292 there were only nine master enamellers at Paris, whereas there were forty during the reign of John the Good.

The themes treated in the Ile de France, in Burgundy and in the Low Countries were often inspired by the life at court or the romance of chivalry. A clasp might bear a representation of a lady dressed for the

hunt, holding a falcon and a heart in her hands, or a pair of lovers in a garden ('*jardin d'amour*'), or a lady with flowers in her hand or a horseman killing a wild beast set within a circular pattern.

Among the most splendid enamelled jewels of the Gothic period are the medallion in a lady's belt, made in France in about 1380, decorated with swans (Staatliche Museen, Berlin), and the splendid necklace of the Hohenlohe family (Hohenlohe Museum, Schloss Neuenstein), made in Burgundy or the Rhineland in the first half of the 14th century, with its plaque of four gold leaves containing a sapphire alternating with bare copper interlace motifs worked with gold enamel and terminating in a white enamelled rose-shaped pendant with the figure of a jester in the centre. Similar splendid works included the belts with painted figures of the saints by Giovanni da Milano, the jewels that appear in the illuminations of the *Roman de la Rose* or in the portraits of clients in 14th- and 15th-century French and Flemish painting, the great necklaces worn by Philip the Good, his son and his courtiers in the illumination by the Master of the *Girart de Roussillon*.

Contemporary documents give details of the precious collections of jewellery and table-ware on which the great lords spent such immense sums. Philip the Fair of France (1268–1314), owned magnificent vases, plates and jewellery, which were made by the court goldsmith Guillaume Julien who specialised in openwork enamel, and which vied in

splendour with even the objects that the king offered as gifts. In 1298 Mahaut, countess of Artois, bought two gold enamelled headbands at Arras from a lady enameller, Jehanne l'Orfavresse; in 1310 she bought other objects from a Parisian enameller, Renaud le Bourgeois; in 1319 she acquired an enamelled golden crown from another Parisian artist from Artois, Colin de Lens; in 1328 in Paris she had a jar and a small gold goblet re-enamelled by the goldsmith Etienne de Salinas. The inventory of Louis I of Anjou, drawn up in 1379, mentions great table-centre salts, small salts with mother-of-pearl bowls, finger bowls, jugs, knives, a multitude of cups and glasses, every kind of badge, buckle and crown, all enamelled on gold. John, Duke of Berry owned similar treasures including some works made by the great Parisian goldsmith, Allebret. Louis X had a sword embellished with enamels. Even horse trappings could be finely enamelled (a headpiece with alternate incised and enamelled scales may be seen in the British Museum), as well as bridles (Bargello Museum, Florence), hunting horns, leashes and dog collars. The preciousness of the object was due in the first place to the singularity of the form, and many beautiful shapes were taken from nature. While the painters strewed their gardens with dog-roses, ferns and single carnations with delicately hued tones, the goldsmith Hermann Ruissel fashioned eighteen buttons of enamelled gold decorated with broom flowers and mottoes for the wedding of Isabella of France and

Richard II of England (1396). For the same occasion the Parisian Jean Conpère made five golden necklaces enriched with enamels, rubies and pearls, four being destined for the king of England and the dukes of Gloucester, Lancaster and York.

Even liturgical enamelled goldwork was influenced by these heraldic and worldly fashions. The rosary crowns that were worn tied to the belt and which ended in drops of pearls or precious reliquaries were as beautiful as any necklace; liturgical chalices had the same shape as secular goblets; the 'royal gold cup', a ciborium made at Paris in about 1380 for the Duke of Berry who gave it to Charles VI (British Museum, London), is decorated in graceful and 'courtly' tones with scenes from the story of St Agnes like some tragic tale of chivalry, with figures in translucent enamel standing out against a smooth resplendent gold background.

Enamelled pieces were used for apparel, in belts of cloth and leather, as clasps for capes, as decoration for liturgical and secular gloves and in embroidered scenes and patterns as in 13th-century Sicily. Gentlemen and ladies living during the reigns of Charles V and Charles VI heightened the splendour of their costumes with enamelled or incised badges. The inventory of the treasures of John, Duke of Berry, in the early 14th century, describes an embroidered cloth with Mary, surrounded by angels, serving as a clasp for a mantle, and an enamelled crown. Enamels were also used in the embroidered hangings on the

altar in the Sainte Chapelle at Paris; enamelled medallions of the 12th century were used to enrich the mitre of bishop Kettil Karlson, embroidered in the 15th century with pearls and gems (National Historical Museum, Stockholm); in the 15th century enamels of an earlier date were used again at Palermo for the altar frontal of the cathedral.

Meanwhile, the use of enamel to cover the curved surface of statuettes in the round became widespread and marked an important point in the history of enamel art. Precise and detailed information about these works have come down to us from 14th-century inventories, especially the lists of the treasure in the papal palace at Avignon (1314–1376) where the court rivalled those of Anjou, Berry and Burgundy in its magnificent elegance. They were objects of very varied shapes worked in France but not attributed in the inventories to individual names, so that they may have been the work of Sienese or of French goldsmiths. There were, first of all, pieces which were only partially enamelled: a dragon of enamel and silver gilt; a ewer in the form of a winged griffin; another in the shape of a gilt cock with enamelled wings; a salt in the shape of a peacock with neck, wings, claws and tail in enamel and its body covered with pearls; and another cock enamelled in yellow, green and blue. Later the whole surface was enamelled: a cock-shaped ewer, for example, or one in the form of a dog. The description of other objects gives some idea not only of the elaborate refinement of the execution, but

also of the interest in naturalism which was beginning to appear in the art of the time: two monkeys sitting on a base with an enamelled cloak; a ship with a stag, a griffon and the coat of arms of France and Burgundy; a salt bearing a dragon with enamelled wings and a tree behind it clad in green leaves on which two monkeys enamelled in naturalistic colours are holding a candlestick; and a group of gilded shepherds, dogs and a female figure together with white sheep.

As well as these the inventories mention pieces with religious subjects: gold images of the Madonna with robes in white enamel, candle-holding angels with enamelled feet and wings; a Madonna in white enamel with the Christ Child in a light red tunic. It was this white enamel used in the last quarter of the 14th century which heralded the use of coloured enamel in the next century on statuettes and groups modelled in the round. The beauty of works that have survived makes it all the more sad that so much has been lost. Among the surviving works are the luxurious crib, known as the Goldenes Rossel ('golden horse') in the collegiate church of Altötting in Bavaria, dating from 1403, a gift from Isabella of Bavaria to Charles VI, which is of highly refined execution in its surprising polychromy; the little French triptych with the *Pietà* between St John the Baptist and St Catherine, dating from the early 15th century (Rijksmuseum, Amsterdam); the great *Crucifixion* of Mathias Corvinus, kept in the cathedral of Esztergom since 1494, which may have been made in Paris in

the first half of the 15th century. The French technique of enamelling figures in the round was continued in the 16th century, as in the ship carrying St Ursula and her companions in Reims cathedral, a table centrepiece transformed into a reliquary and dating from the early 16th century, according to an inscription mentioning Henry III. One of the most famous examples of this art is the *St George and the Dragon,* executed by H. Schleich in about 1590 (Schatzkammer, Munich), an exuberant ensemble of enamel, gems, pearls, gold and silver.

A group of reliquaries in the form of winged altarpieces belong to the European style that derived from International Gothic, such as a French reliquary of about 1350 (Metropolitan Museum of Art, New York) and the reliquary of the Holy Blood in the church of Sta Maria dei Frari at Venice, a Bohemian work of the second decade of the 15th century with enamelled plaques and saints' figures, or a group of monstrances shaped like Gothic chapels such as the one at Voghera dating from 1406.

SIENESE ENAMELS

Such a colourful art as enamelling could hardly fail to attract the Sienese, and the 14th century in Siena was the golden age of the art of translucent enamels which are the most vividly brilliant of all. This branch of the enameller's art, in which the main rivals were

Paris and Siena, avoided the rigid severe compartmentation technique of *champlevé* and had the advantage of offering greater and more imaginative possibilities of design and pictorial composition. An already long existing goldsmith's tradition in Siena made the city particularly suitable for the new technique as enamelling had been practised there since 1256 by Pace di Valentino, in works which have since been lost. Translucent enamels were first used on a bas-relief by Guccio della Mannaia in a work which can be approximately dated—the chalice of Pope Nicolas IV (1288–1292) in the treasury of the church of S. Francesco at Assisi, which has small enamelled portions where colour was combined with an incisive linear pattern derived from the style of northern European Gothic art.

Because of their great technical expertise and the beauty of their pastes, the Sienese goldsmiths became famous outside Tuscany. Lando di Pietro made the crown (now lost) for Henry VII of Luxembourg at Milan; Pietro di Simone first worked at Naples and then, in 1318, went to Hungary with Charles Robert of Anjou. Products of the Sienese goldsmiths and Sienese enamels travelled throughout Tuscany and Umbria, then to southern Italy and Sicily and finally to the various cities of western Europe with which Siena—like so many other Italian cities—had contacts. Sienese works went to Saragossa cathedral as a gift from cardinal Pedro de Luna who later became the anti-pope Benedict XIII; to England where they

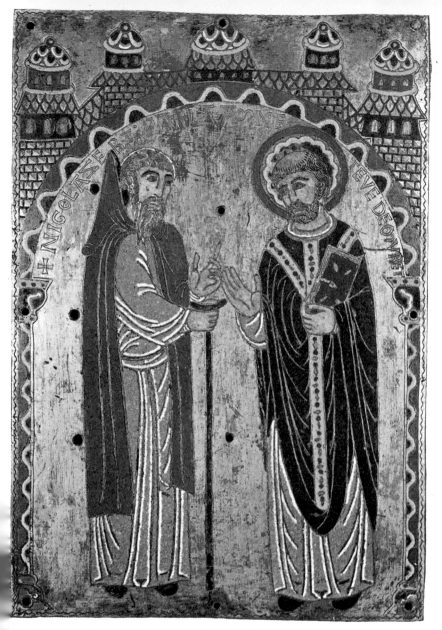

17. Limoges school. 12th century. Plaque. *The Meeting of St Etienne de Muret and St Nicolas de Mirre*. Cluny Museum, Paris.

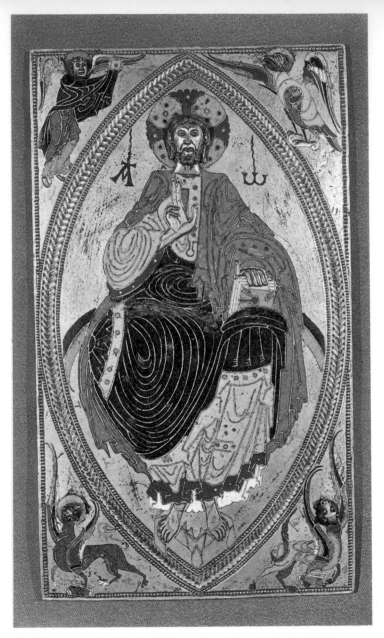

18. Limoges school. Late 12th century. Plaque for the book-binding of an evangelistary. Cluny Museum, Paris.

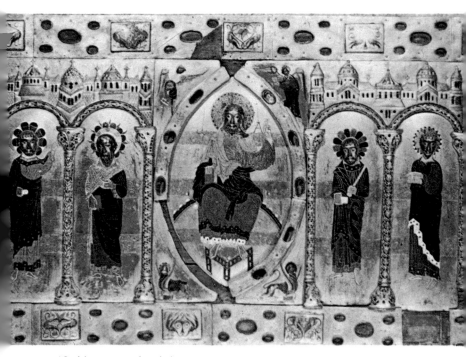

19. Limoges school. Late 12th century. Altar frontal with
Christ in Majesty. Museo Arqueológico, Burgos.

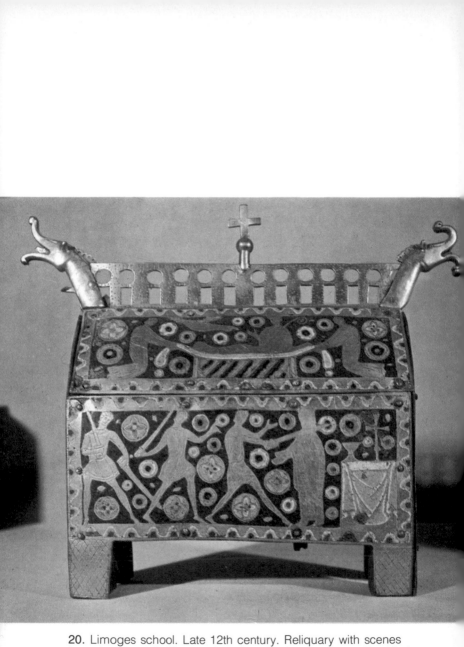

20. Limoges school. Late 12th century. Reliquary with scenes from the life of St Thomas à Becket. Nationalmuseum, Stockholm.

21. Limoges school. 13th century. Pyx. Museo d'Arte de
Cataluña, Barcelona.

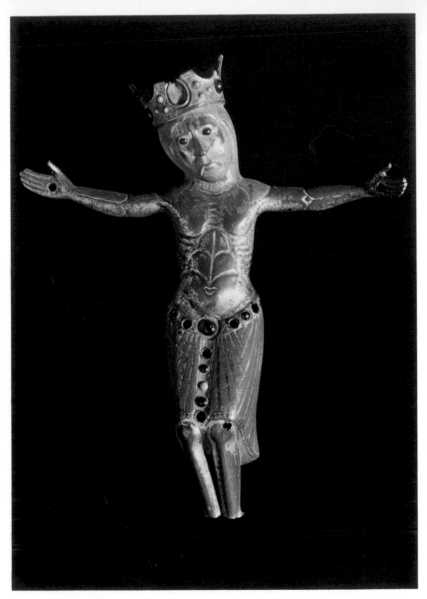

22. Spanish school. 12th or 13th century. Enamelled crucifix.
Museo d'Arte de Cataluña, Barcelona.

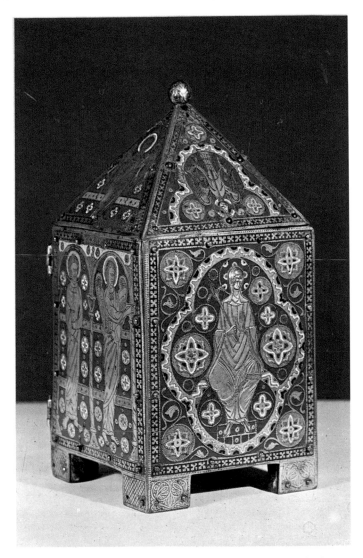

23. Limoges school. 13th century. Ciborium. Louvre, Paris.

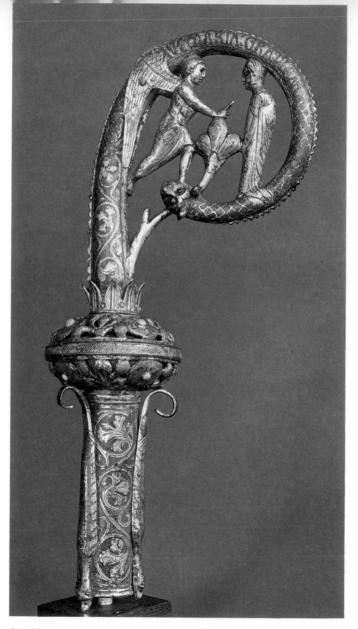

24. Limoges school. 13th century. Crosier with scene of the Annunciation. Louvre, Paris.

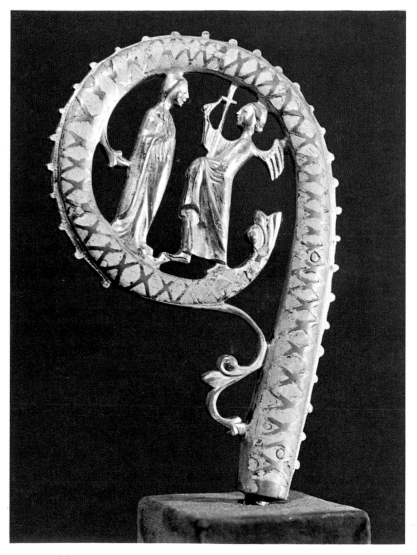

25. Limoges school. About 1200. Crosier with scene of the
Annunciation. Göteborgs Konst Förening, Göteborg.

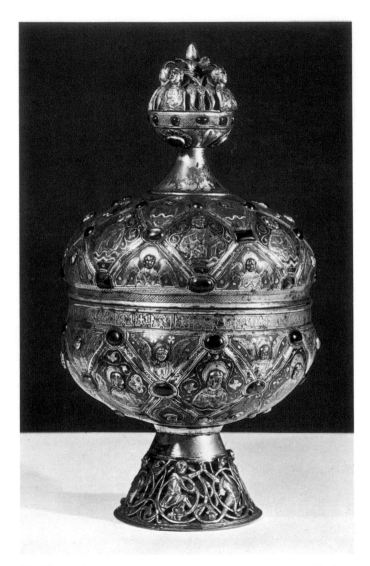

26. Master G. Alpais (13th century). Ciborium. Louvre, Paris.

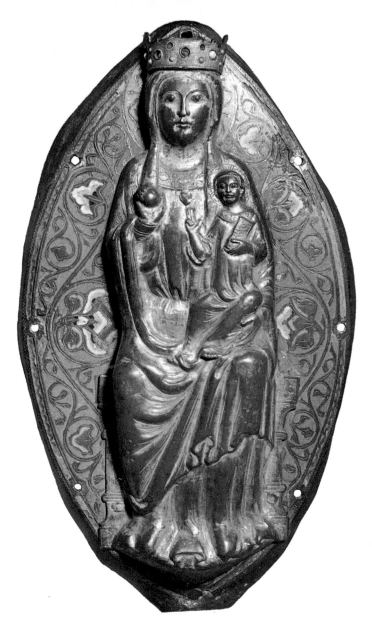

27. Limoges school. 13th century. Plaque. *Madonna and Child*. Musée des Beaux-Arts, Dijon.

28. Limoges school. Late 13th century. Plaque from a reliquary showing St Francis of Assisi. Cluny Museum, Paris.

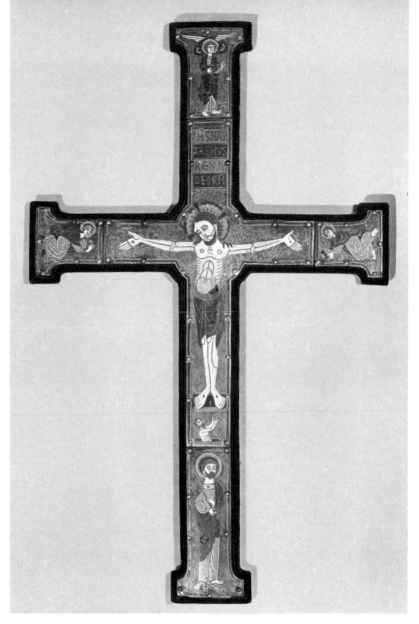

29. Limoges school. 13th century. Large crucifix with *champlevé* enamelling. Museo Poldi Pezzoli, Milan.

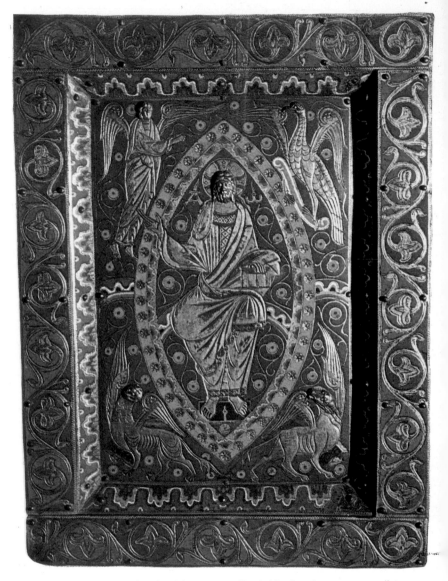

30. Limoges school. 13th century. Book-binding for an evangelistary with Christ in Majesty. Victoria and Albert Museum, London.

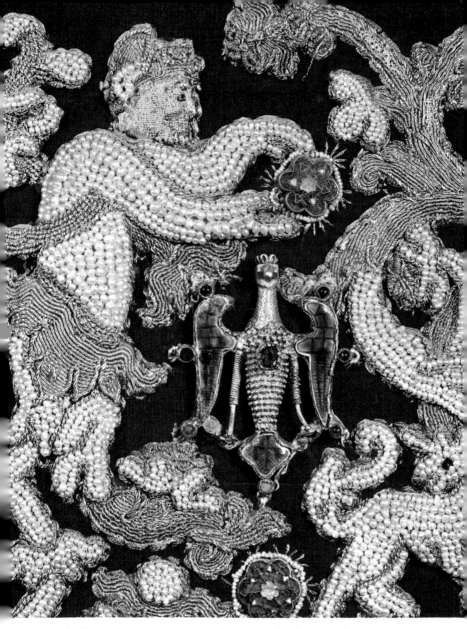

31. Enamelled eagle and small plaques (14th century).
Cathedral Treasury, Palermo.

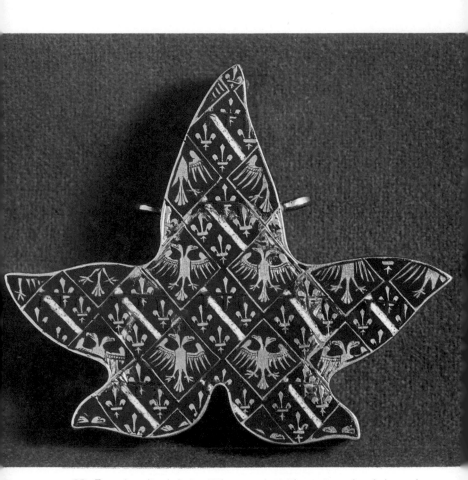

32. French school. Late 13th or early 14th century. Leaf-shaped pectoral plaque. Museo Archeologico, Cividale.

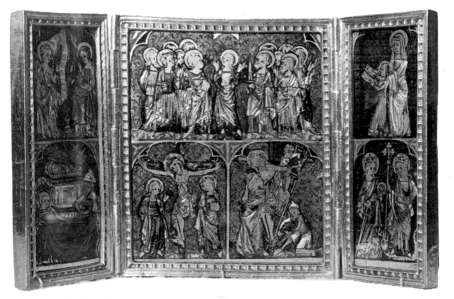

33. English school. 14th century. Triptych with translucent enamels. Victoria and Albert Museum, London.

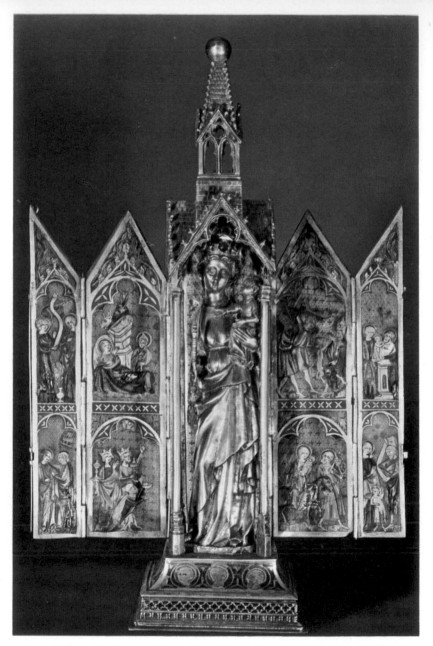

34. French school. 14th century. Small shrine with a *Virgin and Child* and scenes from the Childhood of Christ. Museo Poldi Pezzoli, Milan.

35. Gothic art. 15th century. Chalice. Museo Poldi Pezzoli, Milan.

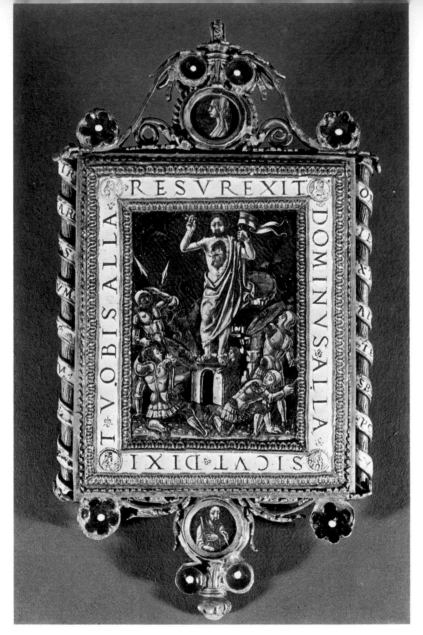

36. Lombard art. Late 15th century. Pax. Museo Poldi Pezzoli, Milan.

37. Venetian art. 15th century. Enamelled copper pyx. Bargello Museum, Florence.

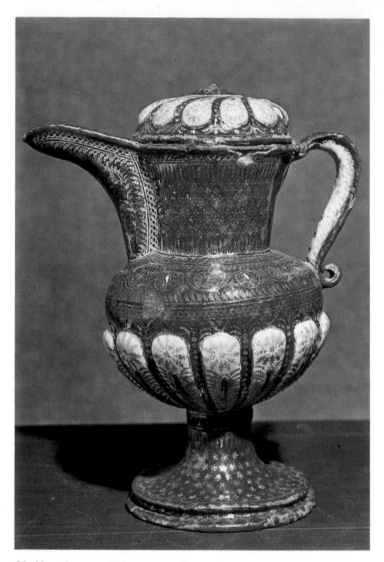

38. Venetian art. 15th century. Enamelled copper jug.
Bargello Museum, Florence.

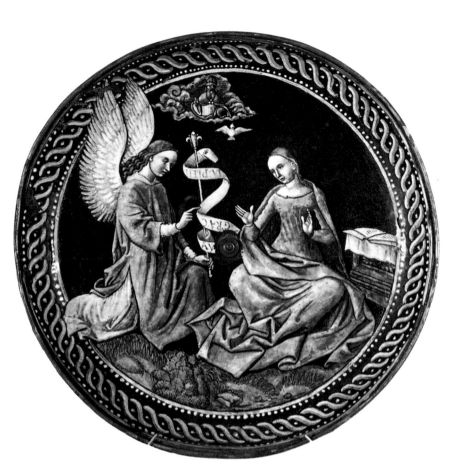

39. Jean Pénicaud (active 1510-1540). *Annunciation*. Victoria and Albert Museum, London.

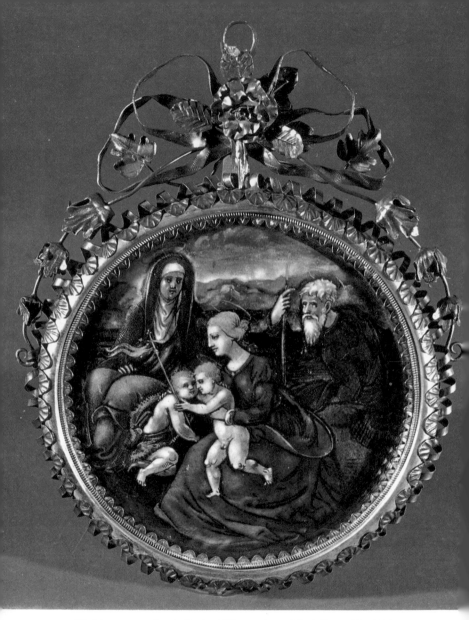

40. Limoges school. Early 16th century. Medallion. *The Holy Family with St Anne and St John.* Museo Poldi Pezzoli, Milan.

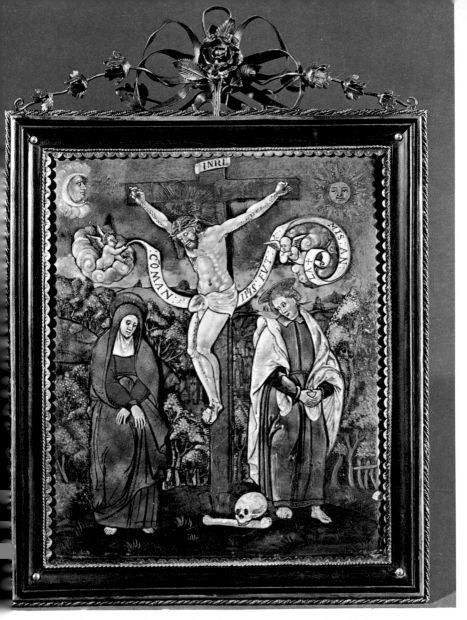

41. Limoges school. Early 16th century. Plaque. *Crucifixion with Mary and St John*. Museo Poldi Pezzoli, Milan.

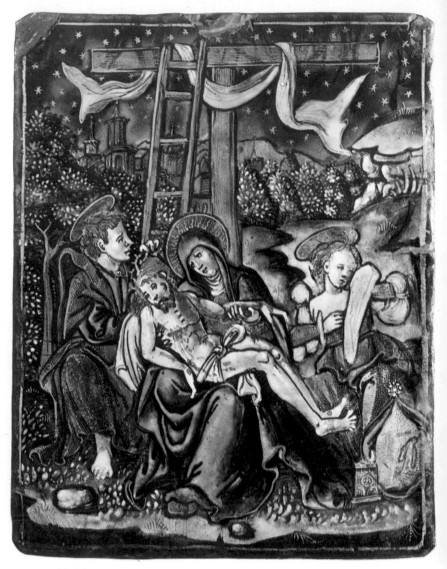

42. Limoges school. Early 16th century. Painted enamel plaque. *Pietà*. Museo Poldi Pezzoli, Milan.

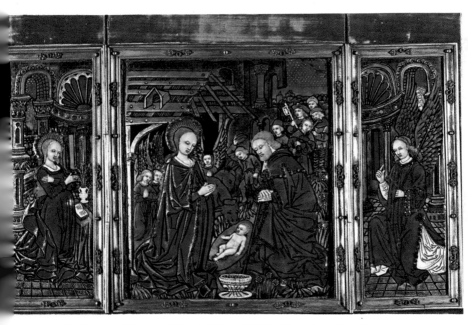

43. Nardon Pénicaud (*c.* 1470-*c.* 1542). Triptych. *Adoration* and *Annunciation*. Bargello Museum, Florence.

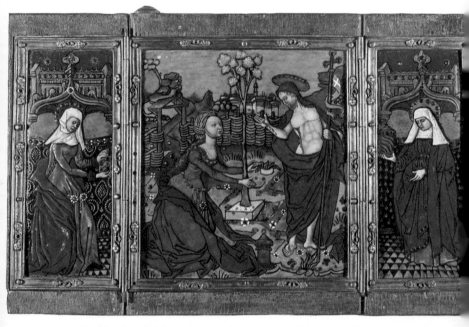

44. Nardon Pénicaud (*c.* 1470-*c.* 1542). Triptych. *Noli me tangere.*
Bargello Museum, Florence.

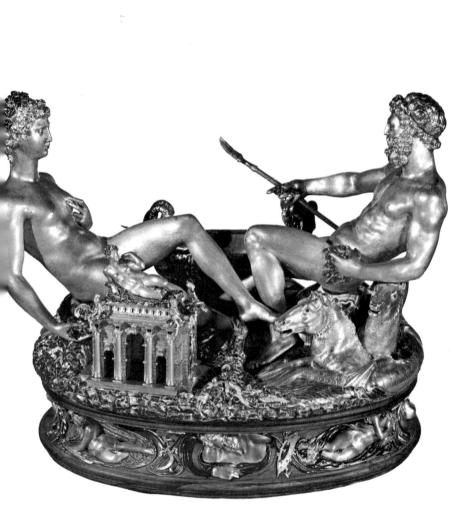

45. Benvenuto Cellini (1500-1571). Gold and enamel salt.
Kunsthistorisches Museum, Vienna.

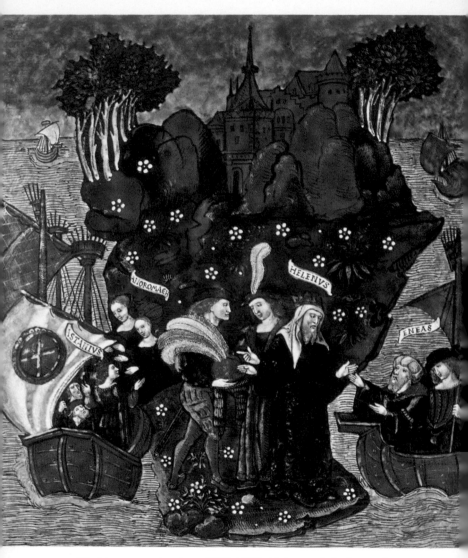

46. Limoges school. *c.* 1525-1530. *Helen and Andromachus offering Gifts to Aeneas.* Metropolitan Museum of Art, New York.

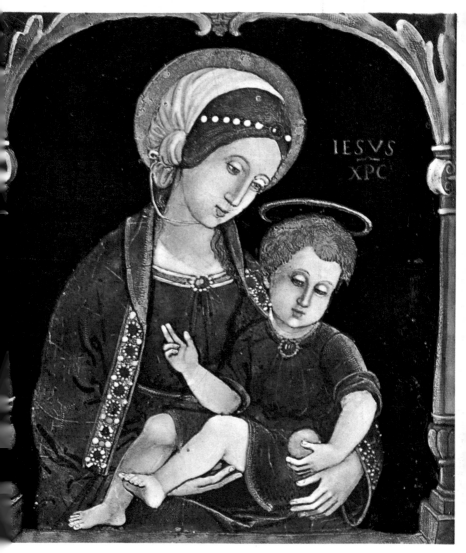

47. Jean II Pénicaud (active 1530-1588). Plaque. *Madonna and Child*. Bargello Museum, Florence.

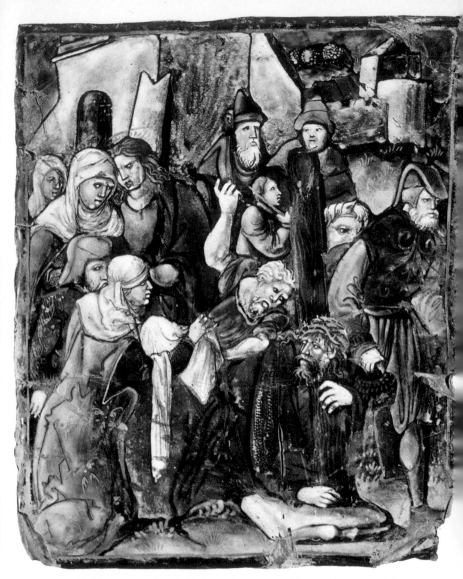

48. Limoges school. Early 16th century. Plaque. *The Road to Calvary*. Museo Civico di Castel Ursino, Catania.

were soon being imitated; and to France where the first work using the new technique can be accurately dated, since it was offered by Jeanne d'Evreux to the abbey of St Denis in 1339 (Louvre, Paris) and was decorated in translucent enamel with fourteen scenes of the Passion on the base. Sienese goldsmiths were also active in southern France. Toro da Siena worked at Avignon from 1309 to 1330 for popes Clement V and John XXII; Giovanni di Bartolo, goldsmith at the papal court, stayed at Avignon from 1364 to 1368 and from 1373 to 1385, and also made a brief visit to Rome in 1372. Both he and Giovanni di Marco executed two no longer extant bust-reliquaries of St Peter and St Paul which were given by Urban V to the basilica of S. Giovanni in Laterano and which probably came from France in about 1369. A surviving work by Giovanni di Bartolo is the reliquary of St Agatha (Catania cathedral) which was commissioned in France by Bishop Martial in 1376. Like many French reliquaries, it was shaped as a bust with two kneeling angels holding up the saint's hands and is largely covered with enamel, the face being coloured with flesh tints. A certain 'Picinus de Senis' also signed a chalice of the early 15th century, now in the museum at Lyon.

Other Sienese goldsmiths worked in the 14th century at Naples where it is probable that they had contacts, either direct or through their works, with their French colleagues Etienne Godefroid, Guillaume de Verdeley and Milet d'Auxerre, the makers

in 1306 of the bust of St Januarius covered with enamels and gems (treasury of the church of S. Gennaro, Naples). Another group of French goldsmiths were also active at Naples in later years. It would appear certain that when Simone Martini painted his *St Louis of Toulouse* in that city in 1317 he must have seen some French enamels at the Anjou court of Naples since he fastened the saint's cope with a magnificent clasp which is a masterpiece in its own right. We may therefore conclude that the exchanges and crosscurrents between French and Sienese painting and sculpture that were so frequent in the 14th century also occurred in enamel art.

The greatest treasure of Sienese jewellery is the great reliquary in Orvieto cathedral which was made in 1338 by Ugolino di Vieri and his Sienese assistants to contain the corporal of the miracle of Bolsena.

As was the case with the pulpit at Klosterneuburg, enamelwork was used for a great narrative purpose. In the eight concave panels of the base and the twenty-four rectangular sections of the two main sides of the reliquary, the stories of the Passion and the miracle of Bolsena are told in a series of scenes which are contained within the framework of the decorative friezes, themselves treated with translucent enamel, as well as the base, the cusps with angels and prophets on the pinnacles, and the terminal cross. The predominant dark blue, azure and light greens set beside the pinks, violets and yellows result in a crystal-clear pattern of colours. The liquid fluidity of the trans-

lucent pastes is in harmony with the sinuous linear patterns and reflects the dazzling iridescence of the metal base, thus creating an enchanting and astonishing effect achieved by few other works in the history of enamel art. The grandiose scale of the composition treated in perspective, the fluent movement of the figures and the beauty of the colouring which seems to change from one moment to the next raise this masterpiece to the same high level as that of the contemporary Sienese paintings and sculptures, to the work of Duccio di Buoninsegna, Simone Martini, Pietro and Ambrogio Lorenzetti and Lorenzo Maitani that Ugolino must certainly have seen and meditated over. But apart from the composition of the figures and the enamelling, the work is important by reason of its architectural design, for its tricuspidal form, divided by high pinnacles, is a repetition of the vibrant design of the façade of Orvieto cathedral. The structure—already widespread in France with reliquaries conceived as miniature models of cathedrals—here becomes a kind of light airy framing so that the colour of the translucid enamels can predominate over the architectural parts and the relief figures.

To Ugolino must also be attributed the reliquary of St Galgano at Frosini (Siena) which is decorated with enamelled scenes from the life of the saint which rival those of Orvieto for beauty. His collaboration with Viva di Lando produced the head reliquary of St Savino (Orvieto cathedral museum) and a chalice,

signed by both artists, which has permitted the attribution of the paten with the *Annunciation* (Galleria Nazionale dell'Umbria, Perugia).

The Sienese school which felt Ugolino's influence produced a cope-clasp with an *Annunciation* (Victoria and Albert Museum, London) which comes even closer to painting in its effect and especially to that of Simone Martini, above all in its stress on chiaroscuro for certain parts. The technique and art of translucent enamelling in France and Italy soon spread throughout Europe. In Spain it was quickly adopted, between 1320 and 1358, for parts of the retable in Gerona cathedral. In England where enamels were used even for tomb slabs, as in the tomb of Sir John d'Abernoun at Stoke d'Abernon (1271) and that of Bishop William Merton for which the artist Jean of Limoges was commissioned in 1276, it was also used for small triptychs and diptychs (Victoria and Albert Museum, London), influenced by the miniature school of East Anglia. In Germany, although an important group of plaques with opaque enamel on copper maintained the stylistic tradition of the altarpiece of Klosterneuburg, craftsmen in the upper Rhineland used the translucent enamels on silver.

Enamelwork came to occupy a prominent position in all Italian Gothic jewel-making, especially in liturgical plate, for its brilliant colour heightened the delicate effect of the incised and relief parts of ornaments and the sumptuous effects of gold and silver. The notable changes in the design of the objects of

this period were determined by the requirements and effects of enamelled decoration. Thus, in chalices, the 'knop' halfway up the stem was enlarged by the additional protuberances designed to carry the plaquettes with enamel motifs which were also repeated on the base in a style that was popular throughout the 15th century.

Enamels were often used for the centres of patens (Galleria Nazionale dell'Umbria, Perugia); in processional crucifixes in Tuscany, Umbria and the Abruzzi (that of Rosciolo, in 1334, in the Museum of the Palazzo Venezia, Rome, is one of the most important) and in northern Italy where they were exceptionally combined with miniature painting as in the rock-crystal cross-reliquary in the treasury of S. Francesco at Assisi. They were used for plaques on bust-reliquaries, either in the quadrilobe decorations of vestments and mitres (bust of St Donatus in Cividale cathedral, made by Donadino in 1374; of St Zanobi in Florence cathedral, executed in 1331 by Andrea Arditi; of St Donatus in the parish church of Arezzo, executed by Pietro and Paolo Aretini; of St Ermagora, about 1340, in the museum of Gorizia), or in the decorations of the base (reliquary of St Giovanni Gualberto in the abbey of S. Michele at Passignano in the Val di Pesa). Enamels were also used in Gothic tabernacle-reliquaries (that of St Reparata, Museo dell'Opera, Florence cathedral); in altars (altar pedestal with figures of Christ, Mary and the apostles executed in 1313 by Andrea Pucci

of Empoli for the Florentine baptistery, now in the Bargello Museum; altar of St James in Pistoia cathedral).

Enamels continued to be used for church plate in Renaissance Italy but there was a return to opaque enamels as in the great reliquary of the Holy Cross made in 1474–1475 by Bernardino delle Croci of Parma for the old cathedral at Brescia; in the reliquaries of St Girolamo (1487) and of St Anthony (1514), both in Florence cathedral; the reliquary of St Giovanni Gualberto (abbey of Vallombrosa, Reggello) dated 1500 and signed by Paolo di Giovanni Sogliani, also noted for his beautiful so-called book-reliquary (Florence baptistery), with its polychrome enamels on the façade which was shaped like a Renaissance altar. At Siena another great master enameller who flourished in the 15th century was Francesco d'Antonio who in 1459 made charming borders of coats of arms and flowers with fresh lively colours for the casket containing the cowl of St Bernard (church of the Observance, Siena), and the reliquary containing the arm of St John the Baptist in 1446, which can still be seen in the Museo dell'Opera of Siena cathedral. But while painted enamelwork was following a path that brought it increasingly close to painting, other enamels used for sacred and secular art always had a more restricted application and the goldsmith-sculptor became more important than the goldsmith-enamellist.

It is not known where the art of painted enamel on

copper began in the middle of the 15th century, although it may have been Flanders. The great painter and miniaturist Jean Fouquet left one of the few surviving examples of this technique in his half-length self-portrait painted, with the name, on a round plaque (Louvre, Paris) which, if it comes from the altar at Melun, must date from about 1450. In the piece, unique among Fouquet's works, the luminosity of the material and the strong relief of the gold modelling stress all the characteristics of his style to an extraordinary degree—his balance, simplicity, and seeking after every physical detail of the face to obtain powerful psychological individualisation, and his lively plastic sense. The unique dazzling effect of the modelling is obtained by means of a special process, *enlevage à l'aiguille,* by which the artist would scratch the colour or the gold with a needle so that the underlying metal would show through. The lightness or heaviness of the scratching would also result in a greater or lesser chiaroscuro effect—as with incisions on metal—and consequently all the effects of relief and light that the artist could wish for. Nothing comparable in artistic excellence is found in the painted enamels of the 15th century or the early 16th century, which continued to repeat the forms of Gothic miniatures and painting. These works were often rectangular in shape and therefore appeared as small pictures, which were sometimes articulated in the form of a triptych, and they were almost always destined as lordly domestic ornaments.

In France, in the second half of the century, a group of works by different artists was attributed to the fictitious 'Monvaerni' because of a badly read inscription. Gaudily coloured with metal foil that produced a rather pleasing effect, they have a certain solemnity as well as a ponderous archaic insistence on stereotyped religious themes and iconography. Many other works can be grouped either by the names of the enamellers or by monograms (K.I.P., M.I., M.P., I.C.) and the workshops from which they came, like the one called the workshop 'of the big foreheads', and those that produced the Orléans and Louis XIII triptychs.

A whole family would often work together or transmit the art from father to son. The Pénicaud family came into prominence as enamellers in Limoges and with them the city found its second great period in the history of enamel art. The founder of the family, Nardon (c. 1470–c. 1542), still remained faithful to the Gothic tradition, drawing his inspiration from Books of Hours, but his colouring was lively and fresh. He made several triptychs, including the rather beautiful *Noli me tangere* (Bargello Museum, Florence) and the great plaque (1503) in the Cluny Museum, Paris, with the *Crucifixion* and the two donors kneeling below in a work in which the green, purple and pink stand out against a deep blue background covered with lilies. Jean I Pénicaud (active 1510–1540), who may have been Nardon's brother, was more open to innovations, and like his followers

made use of the grisaille technique in his enamels, with varying layers of white on a black background, thus obtaining effects of diaphanous transparency against dark shadows. Jean II Pénicaud (active 1530–1588) was an expert technician and highly skilled in grisaille work, often making copies of Flemish and Italian prints as, for example, on the cup dating from 1539, with the story of Samson (Victoria and Albert Museum, London) after Parmigianino. Jean III and Pierre Pénicaud continued the family tradition, making enamel copies of paintings of the school of Fontainebleau.

Artists painted with enamels in northern Italy in the 15th and 16th centuries, first using bright colours and then the darker colours that characterised the second Limoges period, with opaque blues for backgrounds. In Lombardy a great many 'paxes' (tablets with religious scenes, generally including a *Crucifixion*, used during the mass) were produced, like the one in the Museo Poldi Pezzoli, Milan. Some may be dated fairly accurately and assigned to a donor, like that with the initials and insignia of Filippo Maria Visconti (1412–1447) in the church of S. Ambrogio, Milan. In the 16th century it became fashionable to make enamel portraits set inside a medallion. Léonard I Limousin was one of the greatest masters of this art in the second half of the century. He was called to Paris where he became the king's enameller and executed a great many portraits of princes and courtiers, some seventy being identifiable, including

Francis I, Henry II, Queen Eleonora of Austria, the Constable Montmorency, Catherine de' Medici and Antoine de Bourbon. In the course of his long career he practised enamel art on a varied series of objects such as candlesticks, ink-stands, vases and chessmen (Louvre, Paris). He also collaborated with a Mannerist painter, Niccolò dell'Abate, on the altarpiece for the Sainte Chapelle in Paris, with the figures of Henry II and Catherine de' Medici below the *Resurrection* (Louvre, Paris).

But the elaborate colour ranges of the paste, and the mastering of techniques to resolve the most difficult problems in the applying of enamels did not always mean a correspondingly high artistic level. In other words, the great possibilities for refinement in the figure composition, according to the degree of technical expertise attained, made enamel art into something like a copying technique by which existing paintings could be reproduced in more durable form.

Wood-cuts and engravings began to appear in enamellers' workshops and were already serving as models in the early 16th century. One series of enamels is based on a series of prints of scenes from the *Aeneid* published at Strasbourg as illustrations from Virgil's works (Louvre, Paris). The practice of reproducing prints (enamel versions were made of prints by Marcantonio Raimondi, Jean Cousin, Lucas van Leyden, Dürer, etc.) and even famous paintings in enamel was characteristic of the work of many late 16th-century artists such as Pierre Reymond and

Jean Court, known as Vigier, whose works travelled quite far outside Limoges. Léonard Limousin executed a series of plaques with scenes from the story of Cupid and Psyche taken from prints by Raphael. Even more popular were jugs, plates and goblets, the last two being generally executed in grisaille both inside and outside, with elegant black and white patterns and gold friezes. Enamel was also used for architectural decoration and furnishings and nine very large plaques (65 in. × 40 in.) with figures of the Virtues and ancient deities have survived after having been part of the external decoration of the Palais de Madrid built in the Bois de Boulogne by Francis I (Cluny Museum, Paris).

Even when the most prized qualities of manufactured objects were their beautiful shape and the sumptuousness of their material—as in the case of rock-crystal which was made all the more limpid and luminous in appearance by finely incised line patterns or wonderfully coloured semiprecious stones—the fashion for variety of materials in a single work still persisted. In the Mannerist and Baroque periods minerals were accompanied by gold and enamels which might have a limited application but still had a role that was by no means secondary.

In fact in vases whose bodies are carved out of rock-crystal or semiprecious stones the mounts are of gold and make full use of enamels; so these handles, rims, feet, and the bands which encircle the knops add their precious gold to the splendour of the gems,

pearls and enamels. The mounts of the frieze might be executed in infinitely varied styles, but restraint and balance in the decoration still predominated, due to the narrowness of the borders; however, in the handles the artist would give full rein to his imagination in tiny masterpieces conceived in a wide range of colours. They were usually grotesque figures, Medusa masks, winged tritons and sirens, and a wide mythological and zoological Mannerist repertory which assumed a monumental character despite the small size of the figures. Many of these details could be enlarged as designs for fountains in the gardens of villas, for door panels, or for stucco decorations for interiors. Consequently it is not surprising that many of the designers were also architects or sculptors, or both, as in the case of Bernardo Buontalenti who made a design for a two-handled amphora to be carved from a block of lapis lazuli, in the shape of a winged sphinx-siren with a long curved gold neck and head (Museo degli Argenti, Florence).

Massive gold mounts were used in the manufacture of rock-crystal vases and contrasted with the apparent fragility and transparency of the material. A large chalice in the Museo degli Argenti in Florence, dating from about 1580, has two splendid golden handles in the shape of winged grotesques (the wings are enamelled with green, blue and red feathers) and tiny polychrome bowls of fruit set at intervals along the rim. In the same museum the splendid chalice made for Henry II of France and his mistress Diane

de Poitiers has an openwork lid in gold-enamelled black and white, and the central node of the bowl is decorated with a remarkable brilliant red transparent enamel in a pomegranate-seed pattern. This was the 'red' enamel which Cellini said had been invented by 'a goldsmith who delighted in alchemy ... attempting to make gold'. Also in the Museo degli Argenti in Florence are a crystal sea-shell with an enamelled handle in the shape of a dragon and a large crystal vase in the form of a boat and a triton, with enamelled gold handles and rims decorated with masks. A casket of rock-crystal and silver gilt, made by Valerio Belli in 1532 and given by Clement VII to Francis I as a wedding present for his niece Catherine de' Medici and the Duke of Orléans, has two enamelled borders covered with tiny flowers and azure backgrounds decorated with the arms of the pope.

The enamelled serpent with gold head and tail on the side of a small, spiral-shaped lapis lazuli cup is the work of the Flemish craftsman Jacques Bilivert. The orange jasper bowl in the form of a hydra, surmounted by a statuette of Hercules, has enamelled rims decorated with pearls, and a blue mask with green eyes in the front. The rims of a red agate chalice and a lapis lazuli chalice are both enamelled in dark colours and date from the late 16th century. A flat flask of red jasper has a medallion with a cameo inside a voluted enamel frame reminiscent of similar frames for cameos that were used in pendants.

Very often several artists collaborated on the same

object as in the lapis lazuli vase with the initials of Francesco de' Medici that Buontalenti designed and for which Bilivert made the gold mounts with red and white and green enamelled parts and imitation red enamelled stones in the base.

The Medici vases in the Museo degli Argenti in Florence belong to a collection begun by Lorenzo the Magnificent and later enlarged by the dukes and grand dukes of Florence. Like the Florentine court, the Imperial court in Vienna, and the courts of the Electors of Saxony, of the tsars and of all the reigning houses of Europe collected cameos, carved crystal, ivories, gems, bronzes and vases of rare or precious materials. As much as or even more so than pictures and antique statuary, these collections became status symbols and were designed to impress guests, especially foreign dignitaries and ambassadors. Francis I, Henry IV, Louis XIV and his son the Grand Dauphin were all enthusiastic collectors and they exhibited their objects in the chambers and small galleries of Fontainebleau, the Louvre, Meudon and Versailles. In the collection of the Grand Dauphin alone, 455 agate vases and chalices, all partly enamelled, were listed.

The names of many of the master enamellists of 16th-century Italy are known. Among them were the Milanese Caradosso, said by Cellini to be 'quite proficient in his art', the Milanese Saracchi, the Florentine Amerigo Amerighi, mentioned in Cellini's appendices to his *Treatise* and *Life*, Michelangelo

Bandinelli, Salvatore Guasconti and Cellini himself, who, after his apprenticeship in his native city with the goldsmith Antonio di Pietro, known as Marcone, spent 'many months' in the workshop of a Sienese craftsman, Francesco Castoro. His long career, from 1518 to 1570, encompassed sculpture, architecture, goldsmith's work, medals, seals, arms, jewellery and enamels. He himself described some of his enamelled work (now lost), such as a jewel shaped like a lily made at Rome in 1523–1524 for the wife of Sigismondo Chigi, 'adorned with masks, *putti*, animals and all excellently enamelled so that the diamonds forming the enamel were made the finer by as much as half again' (*Life*, I, 19); a ring with a 'pointed' diamond of 1546 made for Eleonora of Toledo who gave it to Philip II of Spain, formed of 'four *putti* in the round with four masks . . . some fruit and enamelled mounts' (II, 68). Cellini's great fame as an enamellist is due to his celebrated Vienna salt (Kunsthistorisches Museum) which he began for Hippolito d'Este and finished in about 1543 in Paris for Francis I. The naked figures of the earth and Neptune were left in gold but Neptune's diadem was enamelled (in green) as was his trident (grey) and the cloth on which he is seated (blue and green). The figure of the earth, seated on a golden lily-patterned carpet on a green background, has a headdress of a garland of fruits in green and red. Marine creatures are emerging from the blue waves; the earth is flanked by green, red, azure-blue and yellow fruits; the grey-scaled sala-

mander coming out of the red flames, the boat and the small temple are partly enamelled, and the draperies on the base with the emerging figures of nudes and winds are enamelled in red, green and blue. The work would certainly have had great stylistic unity and formal beauty even without the enamels. But the highly coloured enamels underline the love of minute detail found even in monumental works of the time and the same technical virtuosity that characterised the carving and gilding of the great bronze works of the late 15th century, and in Cellini's own statue of Perseus. They also reveal a taste for excess and a rich hedonism of style which appears even more explicitly in another Florentine work, the fantastic Rospigliosi chalice in the Metropolitan Museum, New York, with a highly successful but fantastic if not downright capricious design, emphasised by the glowing enamels.

Artists continued to make enamelled copper vessels such as water-beakers, pyxes and blue-and-white reliquaries such as those in the Bargello Museum which were made in Venice in the 16th century, and enamelled gold vessels like the four gold cups in the Museo degli Argenti in Florence and a gold flask of 1602 by the Nuremberg craftsman Hans Karl. But all over Europe there was a growing preference for precious materials with even more vivid colours. Of the masterpieces of the early 17th century should be mentioned a beaker in the style of G. Schreiber, with gold bands enamelled in white and green that hold

49. Limoges school. Early 16th century. Plaque. *Noli me tangere.*
Museo Civico di Castel Ursino, Catania.

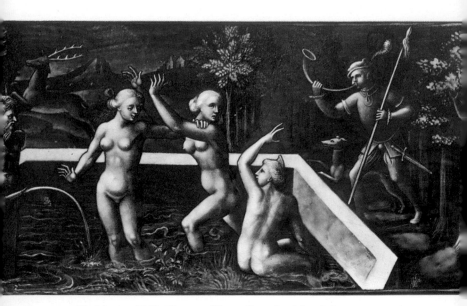

50. Master M.D. Plaque. *Diana Surprised by Actaeon*.
Louvre, Paris.

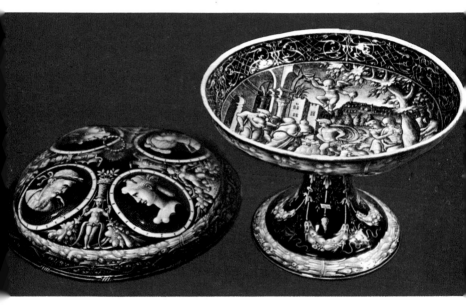

51. Pierre Reymond (*c.* 1513-*c.* 1584). Enamelled cup with a wine-harvest scene, medallions and grotesques. Bargello Museum, Florence.

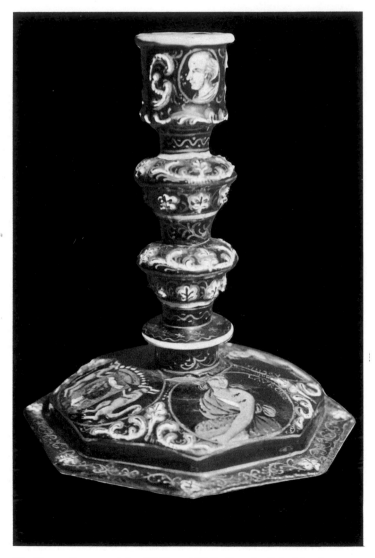

52. Pierre Reymond (*c.* 1513-*c.* 1584). Candlestick. Musée Historique de l'Orléanais, Orléans.

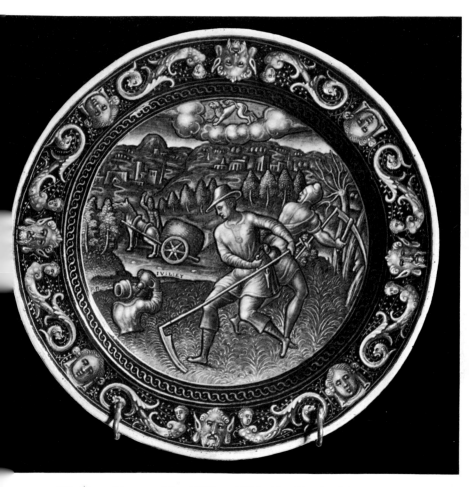

53. Pierre Reymond (c. 1513-c. 1584). *The Month of August.*
Musée des Arts Décoratifs, Paris.

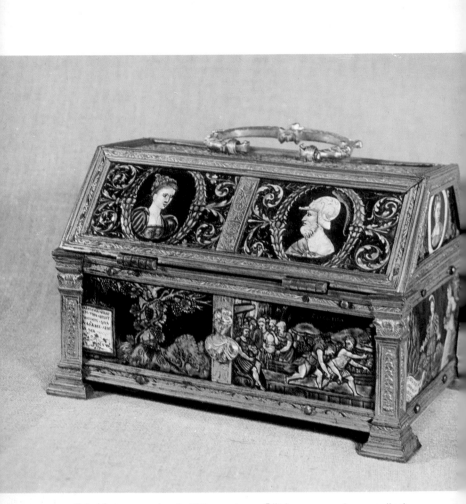

54. Limoges school. 16th century. Gilt bronze and enamelled casket. Bargello Museum, Florence.

55. Italian art. 16th century. Scent spray. Museo degli Argenti, Florence.

56. Florentine school. Late 16th century. Detail of a jasper vase in the form of a hydra. Museo degli Argenti, Florence.

57. Jacques Bilivert (active in the late 16th century). Cup in semiprecious stone with enamelled gold serpent. Museo degli Argenti, Florence.

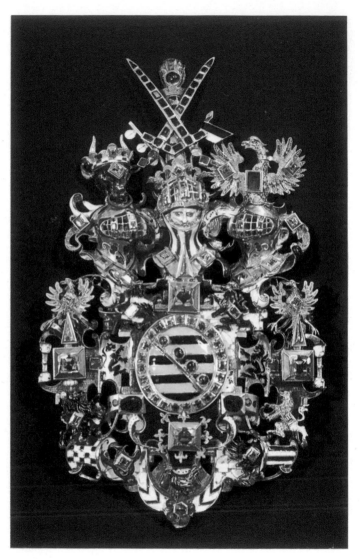

58. German school. 16th century. Pendant in enamelled gold and gems. Grünes Gewölbe, Dresden.

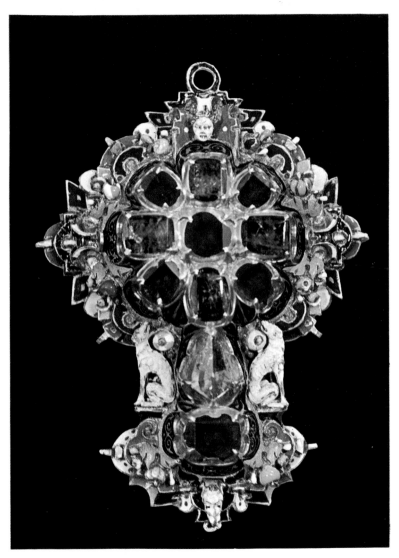

59. German school. 16th century. Pendant in enamelled gold
and gems. Grünes Gewölbe, Dresden.

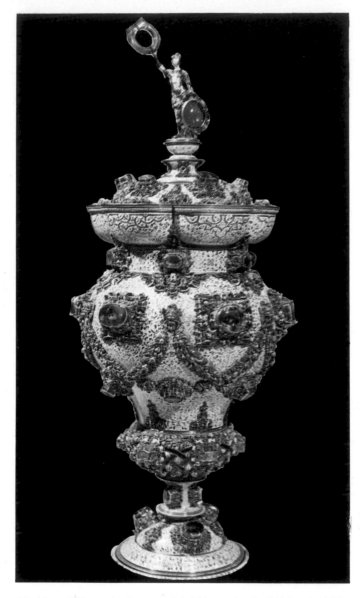

60. Hans Reimer (active *c.* mid 16th century). Gold vase with sapphires and enamels. Schatzkammer, Munich.

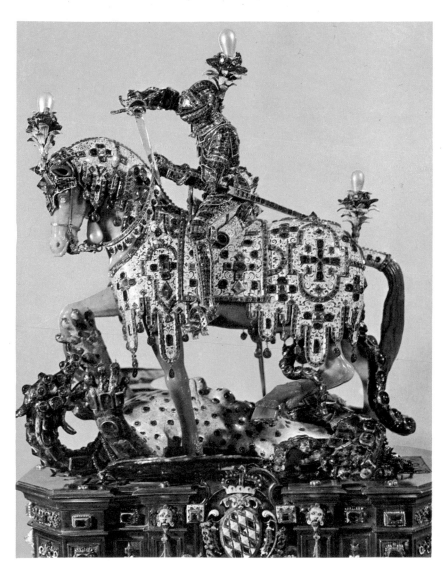

61. H. Schliech (active late 16th century). *St George and the Dragon*. Schatzkammer, Munich.

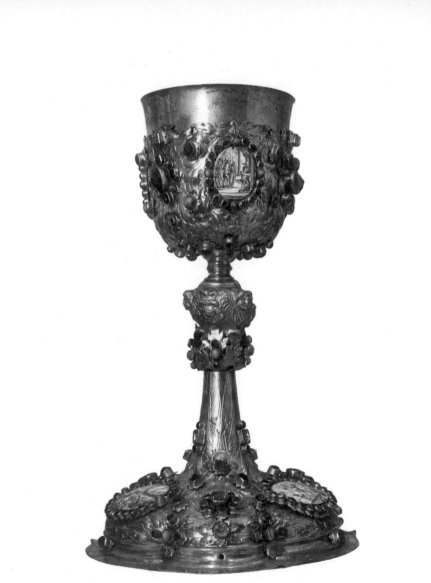

62. Portuguese school. Late 17th century. Chalice.
Kunstschätze, Aachen.

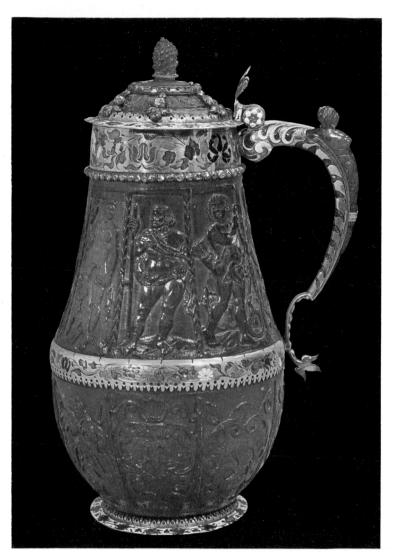

63. Style of Georg Schreiber. Early 17th century. Water jug.
Grünes Gewölbe, Dresden.

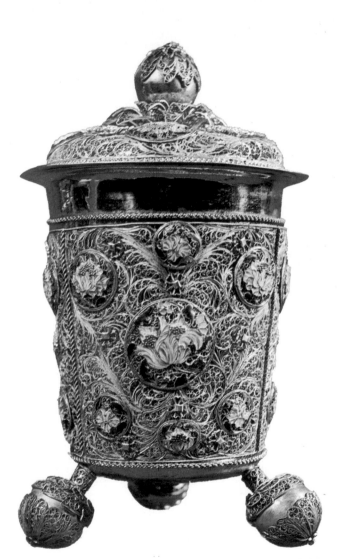

64. R. Wistkopf (active late 17th-early 18th centuries). Vase with filigree decoration and enamels. Nationalmuseum, Stockholm.

together sixteen convex plaques of reddish amber from the Baltic coast, decorated in relief with figures of divinities (Grünes Gewölbe, Dresden).

During the 17th century, enamel art became widespread throughout Europe but it showed an increasing tendency to be considered as one of the 'applied arts'. In Germany a large group of artists, including Christoph Jamnitzer, Friedrich Hildebrandt and Christopher Lencker, were all active, using translucent enamels on surfaces worked in high relief. The Miseroni, a family of Italian enamellists, worked in Prague for three generations and actively helped to diffuse the art as far as Nuremberg where Bartholomäus Pfister (1650–1695) was working.

In the late 15th and early 16th centuries, enamel was used to decorate jewellery in Venice, Florence, Germany, France and Lombardy. Medallions with religious, mythological or allegorical themes in relief were enamelled. Some of the most splendid examples may now be seen in the British Museum, the Cabinet des Médailles of the Bibliothèque Nationale in Paris, the Louvre Museum and the Musée Condé at Chantilly. One particularly striking work is an elaborate German composition with arms and weapons, scrolls, eagles and bands surrounding the coat of arms of the Elector of Saxony (Grünes Gewölbe, Dresden). Sometimes the entire design for a piece of jewellery was provided by a painter. Hans Holbein the Younger not only gave his painted figures enamelled jewellery as in the portraits of

Anne of Cleves (*c.* 1540; Louvre, Paris) and Henry VIII (1540; Galleria Nazionale, Rome), but he even made designs for pendants and enamelled chains (drawings of *c.* 1530; British Museum, London).

From the Renaissance period onwards, enamels were used with increasing frequency to decorate objects of personal use such as perfume sprays, small boxes and knife and fork handles. Craftsmen also made richly fashioned oval frames which generally contained cameos and which served as clasps or pendants—often the work of masters who worked at court—or the 16th-century Spanish pendants in which enamels were used to create geometric patterns and chess-board designs. White enamel was usually used for these sumptuous objects which were then decorated with pearls and precious stones.

In the Baroque period, craftsmen made increasing efforts to create marvellous effects, producing boats, various figures, animals (dogs, dragonflies, fishes and cockerels with enamelled wings and pearl bodies). Stones and enamels were used for imitation bouquets in Spanish brooches and there was a widespread taste for clasps for aigrettes, with a fan-shaped frame covered with diamonds and emeralds. There was a fashion for monstrous figures and grotesques, and toys were made of gold, pearls, stones and enamels like the figures of the court dwarfs at Dresden.

By the early 17th century the technique of enamel painting by laying on each colour in successive layers had fallen into disuse. But enamel painting in

which the colours were applied simultaneously on a bed of white enamel had become very popular. The technique used and the results obtained were very similar to those of porcelain painting. This is why some masters like Jehann Heel of Nuremberg (1637–1709) worked with both porcelain and enamel, and why certain treatises of the late 18th and early 19th centuries put both porcelain and enamel painting into the same category.

The introduction of this technique—already anticipated as much as a century earlier by Léonard Limousin—was due to Jean Toutin (1578–1644) of Châteaudun (none of his works survive) and his famous school of miniaturists. The technique spread to France, England, Germany and Switzerland, in particular to Geneva where the Petitot, father and son, Pierre and Jacques Bordier and the Huaud brothers, specialists in the enamelling of watches and clocks, were all active in the 17th century, producing many fine works (Musée d'Art et d'Histoire, Geneva).

Jean Petitot was born in Geneva in 1607. He settled in England where he was commissioned by Charles I for a portrait which was greatly admired by van Dyck, whose style had inspired that of Petitot. He was also active in France from about 1644 to 1686, always using his fine *pointillé* technique and highly refined in his modelling and colouring. In Windsor castle alone, there are some 250 of his portraits.

The Baroque style also influenced ecclesiastical objects and plate, and led to an emphasis on sculpted

ornamental motifs. In domestic and personal items—
apart from the enamel portraits which Etienne
Liotard made in such large sizes—enamelled mirrors
(as early as 1575, the duchess Claude de Lorraine
acquired a rock-crystal mirror covered with gold,
hanging from a chain) became fashionable, as did
watches which ladies could wear on a chain together
with their fans and mirrors. Enamel was still used to
decorate rings, necklaces and bracelets. In the 17th
and 18th centuries there was a growing vogue for
large and small boxes such as toilet cases and snuff-
boxes with portraits inset in oval frames or decorated
with fashionable Arcadian or amorous scenes exec-
uted with a wealth of refined detail. Enamellists also
often copied the works of painters like Chardin,
Tenier and Boucher.

The decline in enamel art was due to many con-
current circumstances. Not only was there a change in
public taste, but the new production techniques,
added to the break-up of the ancient guild and
apprenticeship systems, meant the end of that old
personal relationship between the craftsman and his
'boy' which was one of the fundamentals of the craft.

Enamel art was one of the many arts and manu-
factures that received a new lease of life during the
Napoleonic period. The Genevan artist François
Soiron became highly successful in Paris where he
executed portraits on enamels and vases for the new
court, including the equestrian portrait of Napoleon
(1806) and the portraits of Napoleon and Josephine

(completed in 1808). Enamel was also used for large-scale works like the two gilt bronze candelabra enamelled in translucent blue—the favourite colour of the early 19th century—which were used at the coronation of Napoleon I and later given by the emperor to Pius VI (Vatican Library, Rome).

While the craze for collecting increased throughout Europe, enamelling became confined to small occasional objects and gifts. Red and white enamel snuffboxes were made for George IV, gaudy Easter eggs for the Tsar Alexander III, and enamelled cigarholders with his coat of arms (yellow and blue) for Leopold Rothschild. The increasingly prosperous middle classes, who had demanded images of the first hot-air balloon experiments on boxes and caskets at the end of the 18th century, were now avid for enamel images of the miraculous new inventions of the 19th century, such as locomotives, steamships and dirigible balloons. It was with such pictures of advancing mechanical progress, or else with weary affected and sentimental repetitions of Arcadian scenes, that the centuries-old history of enamel art came to an end, being used only for toys, consoles, *toilettes,* snuffboxes and watches.

LIST OF ILLUSTRATIONS

1. Byzantine art. 6th century. Gold medallions with *cloisonné* enamels. National Gallery of Fine Arts, Washington. Each medallion bears a frontal half-figure of Christ and the saints in vivid colours. Religious portraits were a frequent feature of Byzantine enamels. The medallions are linked by chains in a simply designed necklace.

2. School of Byzantium. 11th century. Gold plaque with *cloisonné* enamel figures of Christ enthroned between Mary and St John. Vatican Museum, Rome. Together with three other circular plaques, this was part of a silver casket reliquary. Dark blue and two lighter tones of blue are applied on the gold background; gold thread has been used for the draperies; the throne has a pattern of brown heart motifs set against white, and a red and dark blue border.

3. Byzantine art. 12th century. Book-binding in silver gilt, gems and *cloisonné* enamels. Biblioteca Marciana, Venice. As usual in Byzantine goldsmith's work, the enamels have been applied on small plaques bound together by a framework emphasising the hieratic presentation of the portraits.

4. Byzantine art. Detail of the⁺ centre panel of the 'Pala d'Oro'. S. Marco, Venice. This exceptional work formed part of the booty from the sack of Constantinople (1204) and is a collection of eighty-six Byzantine *cloisonné* enamels of varying shapes, quality and date (10th–12th centuries) whose perfect execution is proof of a great artistic tradition. The enamel image of Christ Pantocrator was enclosed by an elaborate Gothic frame decorated with pearls and precious stones during the restoration of the altarpiece in 1345.

5. Nicolas of Verdun (late 12th–early 13th centuries). Detail of the enamelled gold altarpiece in Klosterneuburg abbey, near Vienna. The work was formerly part of the covering of an ambo (an early form of pulpit) before being transformed into a large triptych in 1330. The inscription states that it was commissioned in 1181 by the prior of Klosterneuburg and executed by 'Nicolaus Virdunensis'. Clear-cut stylistic variations are to be seen in both the design and the colour.

6. Ottonian art. 11th century. Openwork brooch. Altertumsmuseum, Mainz. This brooch with its granulated gold thread and enamels shows that Byzantine techniques had been perfectly assimilated. It belonged to the Empress Gisela of Hungary, wife of Conrad II (1204–1039).

7. Godefroid de Huy (second half of the 12th century). *The Healing of Naaman the Leper*. Victoria and Albert Museum, London. The first great product of the Mosan school of goldsmiths' work. The plaque is covered with splendidly coloured enamels and harmony of design is combined with a vigorous treatment of the theme.

8. Workshop of Godefroid de Huy. Centre panel of a triptych with scenes of the Crucifixion and the Passion. Victoria and Albert Museum, London. The triptych dates from about 1150 and is similar in form to the Byzantine reliquaries of the True Cross which came to western Europe.

9. Workshop at Hildesheim. Mid 12th century. Reliquary of Henry II with *champlevé* enamels. Louvre, Paris. The reliquary consists of a quadrilobe plaque on a stand, one side bearing a representation of Christ blessing, which dominates the figures of the three kings, while the other side shows the Emperor Henry II enthroned.

10. Rhenish school. 12th century. Plaques for a crucifix with Biblical scenes. Bargello Museum, Florence. Plaques of this type, generally decorated with scenes from the Old Testament, were mounted on crucifixes similar to that illustrated in Plate 12 and were made in the Rhine valley region. Although the figures are represented on a single plane, both their design and the colours of the enamels give them a plastic effect.

11. English school. Late 12th century. Plaque. *St Paul disputing with the Greeks and Jews*. Victoria and Albert Museum, London. *Champlevé* enamels were also made in England where Mosan and Rhenish enamels had been imported. Analogies with the paintings in St Gabriel's chapel, Canterbury cathedral, and with miniatures of the 12th century are evidence of the English origin of the plaque.

12. Rhenish school. 12th century. Enamelled crucifix decorated with Biblical scenes. Victoria and Albert Museum, London. Enamel plaques with scenes from the Bible have been set in the centre of the cross and on the ends of the arms and upright while the rest of the cross is decorated with small geometrical and floral motifs.

13. Rhenish school. 12th century. Plaque. *Samson carrying off the Gates of Gaza*. Victoria and Albert Museum, London. The most important centre of the Rhine region was Cologne which produced enamels that inspired other enamel manufacturing centres between Westphalia and Lower Saxony.

14. Rhenish school. 13th century. Plaque for a book-binding with Christ enthroned within a mandorla. Germanisches Nationalmuseum, Nuremberg. The dark tones of the enamel, the graded tones near the white areas and the vigorous design have the rather harsh expressiveness that characterised all Mosan Rhenish art.

15. Limoges school. 12th century. Plaque from the tomb of Geoffrey Plantagenet. Musée Tessé, Le Mans. Executed between about 1151 and 1160, this was the first important secular enamel work to come from the school of Limoges and is one of the most important of the Romanesque period. The figure of the king has a certain strict formal severity, and the colours are rather dark which was unusual for enamels of the Limoges school.

16. Limoges school. 12th century. Plaque. *Adoration of the Magi*. Cluny Museum, Paris. From the abbey at Grandmont. The colouring of the enamels on a copper base is extremely varied: three kinds of blue, two kinds of green, red, pink, white and yellow. The transitions from dark to lighter colours are a partly successful attempt to create a relief effect.

17. Limoges school. 12th century. Plaque. *The Meeting of St Etienne de Muret and St Nicolas de Mirre*. Cluny Museum, Paris. From the abbey at Grandmont. This was part of the same work as the plaque in Plate 16. In both plaques, the arched frame and the architectural elements above resemble those on the tomb plaque of Geoffrey Plantagenet. The figures are enamelled on to the smooth surface of the copper gilt.

18. Limoges school. Late 12th century. Plaque for the book-binding of an evangelistary. Cluny Museum, Paris. A splendid example of *champlevé* enamelling. The linear stylisation is highly refined and accompanied by sharp bright colours that are not intended to produce a plastic effect. The brilliant use of the contours and the arabesque patterns of the gold thread are particularly noteworthy.

19. Limoges school. Late 12th century. Altar frontal with Christ in Majesty. Museo Arqueológico, Burgos. The frontal came from the abbey church of S. Domingo de Silos and is formed of enamelled copper plaques on wood. The heads of all the figures are in relief.

20. Limoges school. Late 12th century. Reliquary with scenes from the life of St Thomas à Becket. Nationalmuseum, Stockholm. From the church of Tröno, Hälsnigland (Sweden). The assassination of the saint is dramatically represented with unusual violence in the angular outlines of the *reservé* figures, against a vividly coloured floral patterned background. The double-sloped lid with its decorated ridge bears the scene of the saint's burial, and the two dragons' heads that were later added are clearly Nordic in spirit.

21. Limoges school. 13th century. Pyx. Museo d'Arte de Cataluña, Barcelona. A typical cylindrical *champlevé* pyx of the Romanesque period. Geometric ornamentation with four-leaf rosettes in tondos covers the whole of the box and lid. Limousin enamels spread over the Pyrenees into Spain where they influenced Spanish art.

22. Spanish school. 12th or 13th century. Enamelled crucifix. Museo d'Arte de Cataluña, Barcelona. Even in such small metal sculptures as this, enamel was used. The enamel hemispheres set along the hem of the loin-cloth are in imitation of precious stones.

23. Limoges school. 13th century. Ciborium. Louvre, Paris. The cube form is rather rare. The object is very beautifully enamelled with *reservé* figures on highly coloured enamelled backgrounds, with rosette patterns in various colours.

24. Limoges school. 13th century. Crosier with scene of the Annunciation. Louvre, Paris. The master enamellers of Limoges collaborated with goldsmiths and were often goldsmiths themselves. The most refined products of this collaboration were pastoral staffs such as this one, with its elegant curve, gilt figures and coloured enamels.

25. Limoges school. About 1200. Crosier with scene of the Annunciation. Göteborgs Konst Förening, Göteborg. A lively variation on the theme treated in the preceding crosier, with turquoise blue enamelling used for the staff.

26. Master G. Alpais (13th century). Ciborium. Louvre, Paris. This is the famous ciborium signed by G. Alpais who was a highly refined goldsmith as well as an expert enameller. The imaginative richness of decoration is reminiscent of Byzantine and Near Eastern art.

27. Limoges school. 13th century. Plaque. *Madonna and Child*. Musée des Beaux-Arts, Dijon. The relief figure, a little work of sculpture in its own right, is set on an enamelled background decorated with interlace motifs and small roses.

28. Limoges school. Late 13th century. Plaque from a reliquary showing St Francis of Assisi. Cluny Museum, Paris. A quadrilobe plaque with the saint looking up at a cherub and flanked by trees in blossom which may almost be taken as symbols for the joyousness and religious ardour of the Franciscan order. The figures are enamelled on a guilloche background.

29. Limoges school. 13th century. Large crucifix with *champlevé* enamelling. Museo Poldi Pezzoli, Milan. The figure of Christ is set with the feet over the tomb of Adam against a copper gilt background with fine vermiculated arabesque patterning. Smaller figures are set at the ends of the arms and upright. All the figures were separately executed on plaques and then set on the cross.

30. Limoges school. 13th century. Book-binding for an evangelistary with Christ in Majesty. Victoria and Albert Museum, London. One of many medieval book-bindings with the same theme (compare Plate 24). The floral frieze running around the highly decorated frame is a motif frequently found in 13th-century art.

31. Enamelled eagle and small plaques (14th century). Cathedral Treasury, Palermo. These Gothic enamels were used again in the 15th century for the sumptuous gold and pearl embroidered altar covering in Palermo cathedral. The type of enamel *(émail de plique)* is French and is executed in the technique used in Paris during the 13th century.

32. French school. Late 13th or early 14th century. Leaf-shaped pectoral plate. Museo Archeologico, Cividale. The armorial insignia on the plaque, with two-headed eagles and Angevin lilies on a blue and red field, show that the plaque was a wedding gift—perhaps for the marriage in 1294 of Princess Tamar, the daughter of Nicephorus I Angelus Comnenus Ducas, the despot of Epirus, with Philip II of Taranto. The beautifully worked reverse is decorated with a branch and seven birds.

33. English school. 14th century. Triptych with translucent enamels. Victoria and Albert Museum, London. The work is a fine example of the new, striking possibilities offered by the translucent enamels which reveal the slight relief of the base and allow the underlying gilt to shine through. The use of these enamels—especially during the Gothic period—allowed craftsmen to execute works that were little paintings in their own right.

34. French school. 14th century. Small shrine with a *Virgin and Child* and scenes from the Childhood of Christ. Museo Poldi Pezzoli, Milan. The refined Gothic style of this work has close affinities with French painting, miniatures and sculpture.

35. Gothic art. 15th century. Chalice. Museo Poldi Pezzoli, Milan. A jousting chalice in rock-crystal with an enamelled mount. The refinement of design is outstanding.

36. Lombard art. Late 15th century. Pax. Museo Poldi Pezzoli, Milan. A silver gilt pax decorated on both sides. The front is decorated with a *Resurrection* in which the figures appear to be in relief against a blue sky, surrounded by an inscription in black letters on white. The reverse bears a *Deposition* in relief. Enamel predominates in the overall decoration of the pax which is remarkably well balanced in design.

37. Venetian art. 15th century. Enamelled copper pyx. Bargello Museum, Florence. As this important piece shows, Gothic style predominated in Venetian goldsmith's work and in enamel.

38. Venetian art. 15th century. Enamelled copper jug. Bargello Museum, Florence. Like the preceding piece and two others in the same museum, this jug is covered with opaque enamels, the main colours being azure and white, with some parts in turquoise blue and others finely decorated with tiny golden stars and commas.

39. Jean Pénicaud (active 1510–1540). *Annunciation*. Victoria and Albert Museum, London. The master enameller Pénicaud, who worked in the Limousin, diffused and developed the grisaille technique.

40. Limoges school. Early 16th century. Medallion. *The Holy Family with St Anne and St John*. Museo Poldi Pezzoli, Milan. The composition of the figures shows the influence of Mannerist painting. The painted enamel produces a certain effect of relief in the figures and receding background, and foil is used to heighten the colouring. The elegant frame, dating from the 18th century, is worked in relief and incised and is crowned by a knot of flowers.

41. Limoges school. Early 16th century. Plaque. *Crucifixion with Mary and St John*. Museo Poldi Pezzoli, Milan. A sophisticated perspective composition as may be seen from the foreshortening of Christ's body and the landscape background, which create a plastic effect. There is an interesting survival of medieval themes, such as the personified sun and moon and the mourners.

42. Limoges school. Early 16th century. Painted enamel plaque. *Pietà*. Museo Poldi Pezzoli, Milan. The painted enamel technique consisted of a successive firing of layers of vitreous colours on a copper base that was usually counter-enamelled on the reverse side.

43. Nardon Pénicaud (*c.* 1470–*c.* 1542). Triptych. *Adoration* and *Annunciation*. Bargello Museum, Florence. Gothic linear designs survived in enamel art, especially in the works of Nardon who is considered to be the founder of this family of enamellers.

44. Nardon Pénicaud (*c.* 1470–*c.* 1542). Triptych. *Noli me tangere*. Bargello Museum, Florence.

45. Benvenuto Cellini (1500–1571). Gold and enamel salt. Kunsthistorisches Museum, Vienna. This magnificent centre-piece was begun for Ippolito d'Este and completed in Paris in about 1543 for Francis I. It was one of the main works responsible for introducing Italian styles into France, especially in tableware. In his *Treatise* Cellini claimed that it was the Italians who had first found 'the true way of enamelling'.

46. Limoges school. *c.* 1525–1530. *Helen and Andromachus offering Gifts to Aeneas*. Metropolitan Museum of Art, New York. The scene is still influenced in its composition by the late Gothic style, and its brilliant colouring gives it a fairy tale effect.

47. Jean II Pénicaud (active 1530–1588). Plaque. *Madonna and Child*. Bargello Museum, Florence. The members of the Pénicaud family worked for about a century at Limoges which regained its importance as a great centre of enamel art during the whole of the 16th century.

48. Limoges school. Early 16th century. Plaque. *The Road to Calvary*. Museo Civico di Castel Ursino, Catania.

49. Limoges school. Early 16th century. Plaque. *Noli me tangere*. Museo Civico di Castel Ursino, Catania. Many 16th-century enamel artists were inspired by collections of prints, and enamel versions were made of scenes derived from Raphael, Dürer (the *Noli me tangere* and the *Road to Calvary* in the same museum), Lucas van Leyden, Parmigianino and many others.

50. Master M. D. Plaque. *Diana Surprised by Actaeon*.
Louvre, Paris. The freshness and vivacity of the composition
is heightened by the effects of light produced by the super-
imposed layers of enamel.

51. Pierre Reymond (*c*. 1513–*c*. 1584). Enamelled cup with
a wine-harvest scene, medallions and grotesques. Bargello
Museum, Florence. Grisaille techniques, as used in this highly
elegant chalice signed P. R. and many other 16th-century
works, consisted of the superimposition of white glazes on a
black enamel base. Effects of light and of relief were obtained
according to the thickness of the white layer. The frieze of the
chalice is in gold.

52. Pierre Reymond (*c*. 1513–*c*. 1584). Candlestick. Musée
Historique de l'Orléanais, Orléans. Enamel decoration har-
monised perfectly with the shapes of the exquisite objects
made in the Renaissance. Candlesticks, plates and cups were
decorated with mythological or allegorical scenes and figures,
between friezes and bands of grotesques which were also a
popular feature of stucco and fresco decorations.

53. Pierre Reymond (*c.* 1513–*c.* 1584). *The Month of August*. Musée des Arts Décoratifs, Paris. Pierre Reymond belonged to a family of enamellers and specialised in grisaille ware. The plates were generally enamelled on both sides.

54. Limoges school. 16th century. Gilt bronze and enamelled casket. Bargello Museum, Florence. One of the many refined Renaissance caskets made for domestic use. Medallions with antique style portraits are used in combination with allegorical scenes.

55. Italian art. 16th century. Scent spray. Museo degli Argenti, Florence. This scent spray is enamelled with the arms of the Medici and the Valois and belonged to Henry II's notorious wife, Catherine de' Medici.

56. Florentine school. Late 16th century. Detail of a jasper vase
in the form of a hydra. Museo degli Argenti, Florence. The
strange mask surmounted by the hydra heads is a typical
example of Mannerist fantasy in art. The enameller of the piece,
part of the Medici collection, used vivid colours that were often
translucent.

57. Jacques Bilivert (active in the late 16th century). Cup
in semiprecious stone with enamelled gold serpent. Museo
degli Argenti, Florence. This little shell-shaped cup with a
handle in the form of a serpent is one of the most exquisite pieces
in the Medici collection and is a typical product of the late
Renaissance when such objects were greatly in vogue.

58. German school. 16th century. Pendant in enamelled
gold and gems. Grünes Gewölbe, Dresden. Enamels con-
tinued to be used in important quantities in Renaissance and
Baroque jewellery in every shape, size and colour. The value of
the metal and precious stones was increased both by the
fineness of the execution and the shining colours of the enamel-
ling.

59. German school. 16th century. Pendant in enamelled gold and gems. Grünes Gewölbe, Dresden. The largest collections of 16th- and 17th-century jewels are in the Kunsthistorisches Museum, Vienna, the Grünes Gewölbe, Dresden, the Louvre, Paris, the Museo Poldi Pezzoli, Milan, and the Museo degli Argenti, Florence.

60. Hans Reimer (active *c*. mid 16th century). Gold vase with sapphires and enamels. Schatzkammer, Munich. A splendid example of gold tableware used at the courts of Europe. It was made in 1563 and is enamelled with a design which seems to resemble damascened steel.

61. H. Schliech (active late 16th century). *St George and the Dragon*. Schatzkammer, Munich. This elaborate statuette (height 20 in.), made in about 1590, is remarkable for the refinement of its enamelling, mostly in white, which increases the splendid effect of the pearls, rubies and diamonds so skilfully used in the decoration.

62. Portuguese school. Late 17th century. Chalice. Kunst-schätze, Aachen. Set in the Baroque decoration with friezes and volutes, dating from 1684, the enamelled medallions are reminiscent of those used for decorating the stems, knops and bowls of the Gothic chalices.

63. Style of Georg Schreiber. Early 17th century. Water jug. Grünes Gewölbe, Dresden. The luxurious vessels used at court were made of many precious materials. In this jug, dating from the early 17th century, the dense tones of the amber are heightened by the brilliant greens, whites, reds and blues of the enamel on gold.

64. R. Wistkopf (active late 17th–early 18th centuries). Vase with filigree decoration and enamels. Nationalmuseum, Stockholm. The vase was made in 1696 and the filigree combines with the enamelwork in interlace and foliage patterns.